LAVOIRS

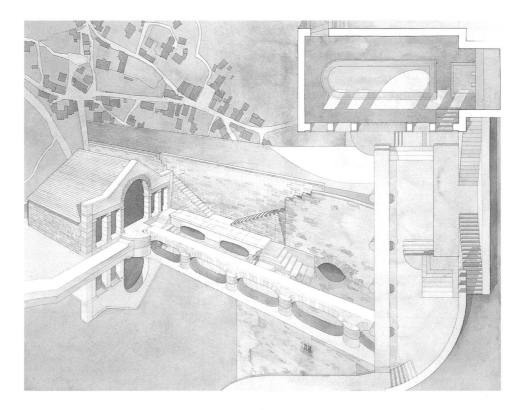

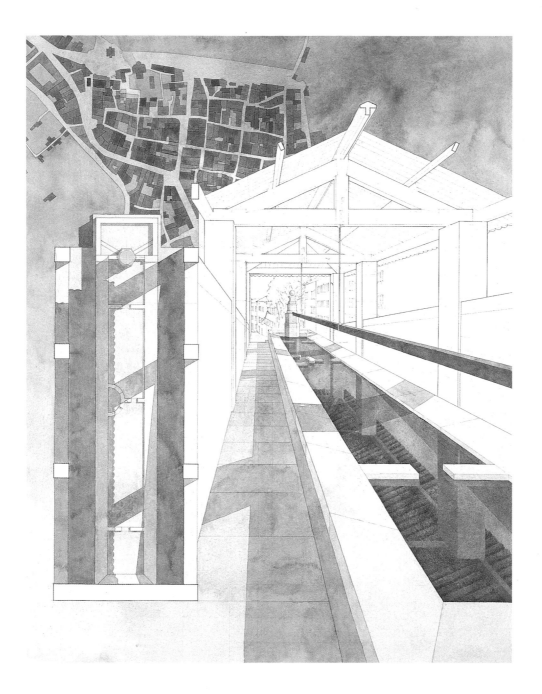

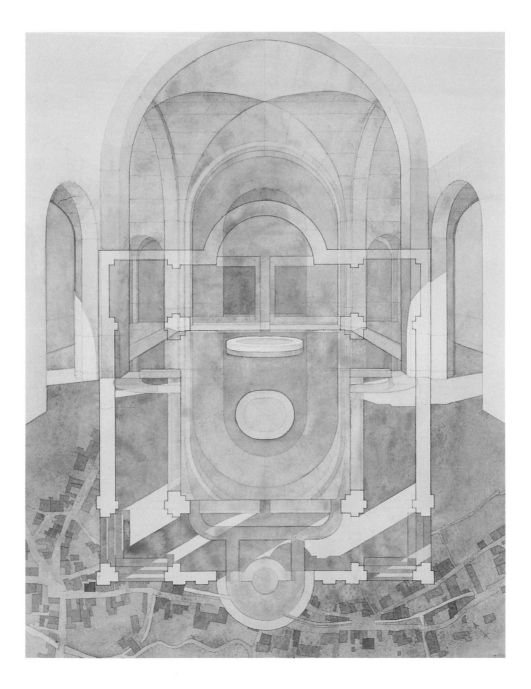

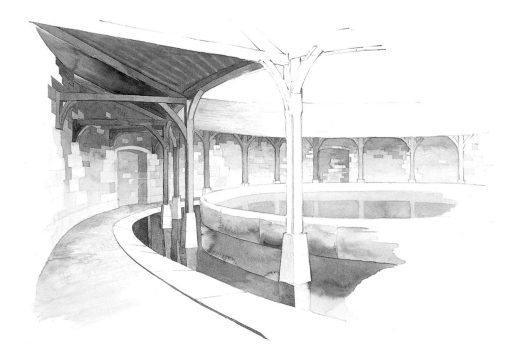

LAVOIRS

WASHHOUSES OF RURAL FRANCE

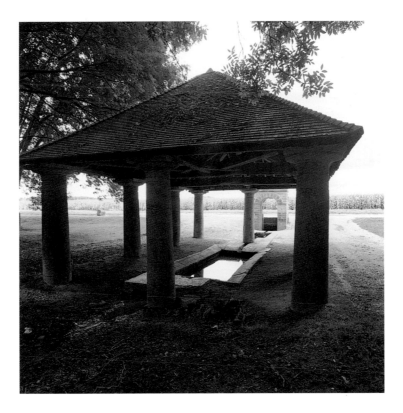

MIREILLE RODDIER

FOREWORD BY BILLIE TSIEN

PRINCETON ARCHITECTURAL PRESS, NEW YORK

PUBLISHED BY
Princeton Architectural Press
37 East Seventh Street
New York, New York 10003

For a free catalog of books, call 1.800.722.6657.
Visit our web site at www.papress.com.

Publication of this book has been supported by a grant from the Graham Foundation for Advanced Studies in the Fine Arts.

FRONT COVER: Lavoir de Villiers, Melle, Deux-Sèvres, Poitou-Charentes, 19th century
BACK COVER: Bourg-sur-Gironde, Gironde, Aquitaine, nineteenth century
COLOR PLATES: Plan and overview, Fondremand, Haute-Saône, Franche-Comté, 1830, architect: Duret; Plan and perspective, Aups, Var, Provence, 19th century; Sectional perspective, Lavoir-Mairie, Bucey-lès-Gy, Franche-Comté, 1827, architect: Louis Moreau; La Fosse Dionne, Tonnerre, Yonne, Burgundy, 1758
FRONTISPIECE: Lavoir de la Fontaine Henri IV, Fontaine-Française, Côte-d'Or, Burgundy, 1807

EDITING AND LAYOUT: Clare Jacobson
EDITORIAL ASSISTANCE: Megan Carey and Nicola Bednarek
COVER DESIGN: Deb Wood

SPECIAL THANKS TO: Nettie Aljian, Ann Alter, Janet Behning, Penny Chu, Russell Fernandez, Jan Haux, Mark Lamster, Nancy Eklund Later, Linda Lee, Nancy Levinson, Katharine Myers, Jane Sheinman, Scott Tennent, Jennifer Thompson, and Joe Weston of Princeton Architectural Press
—Kevin C. Lippert, publisher

LIBRARY OF CONGRESS CATALOGING-IN-PUBLICATION DATA
Roddier, Mireille
 Lavoirs : washhouses of rural France / Mireille Roddier ; foreword by Billie Tsien.
 p. cm.
 Includes bibliographical references.
 ISBN 1-56898-392-1 (alk. paper)
 1. Public laundries—France. 2. Vernacular architecture—France. 3. Laundry—France—History. I. Title.
 NA7010 .R63 2003
 648'.1'0944091734—dc21
 2003000426

CONTENTS

À MA GRAND-MÈRE MIREILLE ET À SON AMIE HENRIETTE,
TÉMOINS DU TEMPS DES LAVOIRS

FOREWORD

Everyday tools and spaces that no longer exist attain a kind of dusty nobility. They are reminders of a recent but disappeared preindustrial age. We find the smokestacks of abandoned factories incredibly poetic. Even collections of milk boxes and dial telephones found at flea markets become physical remembrances of a time just around the corner.

One of my favorite museums is the Mercer Museum in Doylestown, Pennsylvania. Henry Mercer was a tile manufacturer, amateur architect, anthropologist, and autodidact. In 1916 he designed and constructed a private museum of cast-in-place concrete resembling a cement version of Piranesi's work. He collected more than 50,000 tools of various trades and crafts that he saw disappearing from use. All the equipment one needed for making beaver hats, tortoise shell combs, whale-bone art, and gilt clocks is arranged into tableaus of humble production. Objects hung from the walls and ceiling provide a dizzying, gravity defying experience of nineteenth- and early twentieth-century work as if one fell down the Alice-in-Wonderland hole of daily life. It is the commonness of the activity that allows us to understand how the task was performed. It is because we can imagine ourselves doing these tasks that the places where they occur have such poignancy.

These two feelings—a kind of imagined body memory and a sense of loss—are powerful components of the light and dark that are found in the photographs of Mireille Roddier. Her subject is the French laundry. Looking at the photographs, one can so easily imagine the din of voices and laughter as women came together in daily labor to wash the clothes of their families or their employers. The water, now still and clear, would have been roiling and soapy. The stone ledges show the subtle wear of knees and elbows. But now there is silence. The light moves across the water, dust drifts, somewhere there is the sound of water dripping. And what is left are the shells of common labor, now able to be seen as beautiful in Ms. Roddier's photographs. In their stillness as bodies of space containing water, they seem connected to a deeper sense of time. They have a grandeur and monumentality. People have disappeared. The work itself has disappeared. The water continues to flow.

Billie Tsien, December 2002

ACKNOWLEDGMENTS

On a summer visit to my ancestors' town in Burgundy, during the late 1980s, I was saddened by the disappearance of the public washhouse behind our house and by the freshly paved parking lot that had replaced it. The significant demolition of washhouses throughout France made me question and inquire about the *lavoirs*' past lives. It was through Lauretta Vinciarelli's collection of watercolors, published in *Not Architecture but Evidence that It Exists*, that my sentimental interest in water enclosures and my fascination for architectural spaces collided. Vinciarelli opened my eyes to a fact: the old French washhouses belong to the realm of architecture. My attempts to capture the spatial qualities of the *lavoirs* on film have been strongly informed by her work and by James Casebere's atmospheric photographs of flooded spaces.

I could not have condensed the extensive mileage covered through my photography trips without the guidebooks of Christophe Lefébure, Claude Garino, Francine and Jean-Claude Bonardot, Simone Rozenberg, Denis Grizel, and Dominique Berthout, whose work not only provided optimized itineraries but has paved the road in less than a decade for local and national awareness, and a call for the preservation of *lavoirs*.

Kathleen James-Chakraborty, Peter Bosselmann, and Nezar AlSayyad were the first to advise and encourage me when I initially presented them with the idea for this book, and they have been instrumental in its conception.

Several funding groups have allowed this book to come to be. The Western European Architecture Society's annual Gabriel Prize permitted me to spend three months studying *lavoirs* in France. I would like to thank Marion Tournon-Branly for her guidance and encouragement throughout that summer, and for her precious friendship since. I would also like to thank P. J. Fleming, president of the WEAS for his support. I am exceptionally grateful to Richard Solomon and to the Graham Foundation for Advanced Studies in the Fine Arts. Without their vision and generous support, this research would not have materialized. The printing costs for the photographs were largely funded by the University of Michigan's Taubman College of Architecture, and I wish to thank Chairman Tom Buresh and Dean Doug Kelbaugh for their support.

Billie Tsien's thoughtful foreword is truly a gift. Seeing the space of the laundries reflected back to me in her voice was a confirming moment, and I feel honored to have her text introduce the project. I am also grateful to Tod Williams for his critical observations and suggestions.

A heartfelt thanks to all of my friends who have contributed in considerable and meaningful ways: each photographed *lavoir* has a story that is now ours. Hope Mitnick, Cécile Alduy, Solange Delache, Henriette and Sylvain Potam, Jacqueline Bergman, Marie-José and Alain Vin, Marguerite Ventre, Yves Dupont, Dominique and Sandra Fourcade, Vincent Bonino, Louis and Paula Thibaud, René Merle, Jean-Marie Guillon, Marion Sivirine, Joe Slusky and Katie Hawkinson, Cécile Thiebaut, Pauline Rabin-le Gall, Alexandra Sauvegrain, René Cognez, and Dine Le Roux, to all of you, *merci*.

Eric Jeffreys printed all of my photographs. I am thankful to him for his patience, for working relentlessly to meet my deadlines, and for the beautiful prints that he has produced. Melissa Harris and Vincent Castagnacci's help was crucial for the dreadful task of editing the photographs down from the original stack.

I wish to express gratitude to my colleagues Robert Fishman, Will Glover, and Nirmala Singh-Brinkman, who, during the final stages of production, took the time to read the manuscript and offer their expertise and critical feedback. I am most indebted to Caroline Constant for her thorough editing of the text and ongoing encouragements.

Finally, I wish to thank the staff of Princeton Architectural Press for the door they have opened, and especially to my editor, Clare Jacobson, who from the beginning expressed continuous enthusiasm and endless patience.

This book would not exist without the confidence and assistance of my immediate support group: my family, brothers, and especially my parents, who accompanied me on endless excursions as an excuse to share time together, developing an incomparable efficiency with taking measurements and setting up camera equipment, and Keith Mitnick, who never ceased to fluff my aura.

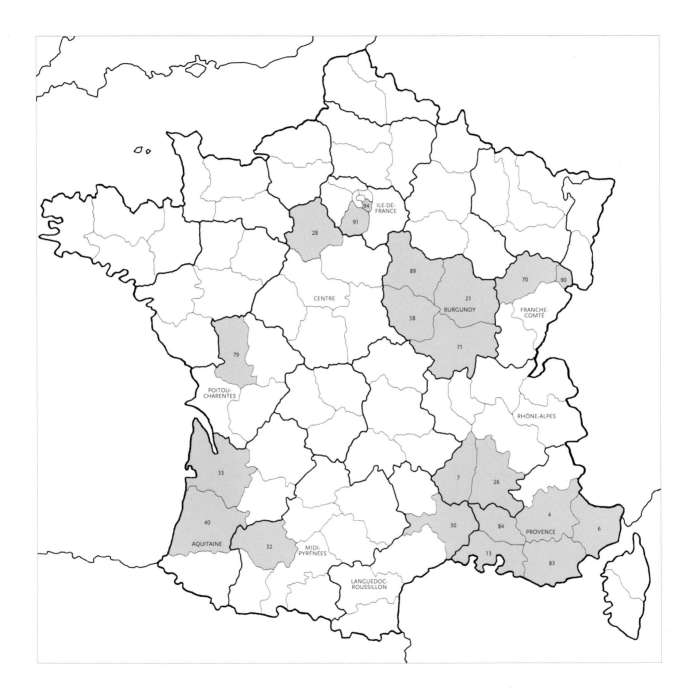

INTRODUCTION

This lavoir owes its existence to the concerns of Norbert Boulet, mayor of this commune, who on July 15th 1813, laid its foundation stone; may his successors always show similar zeal towards public service. —Dilo, Yonne

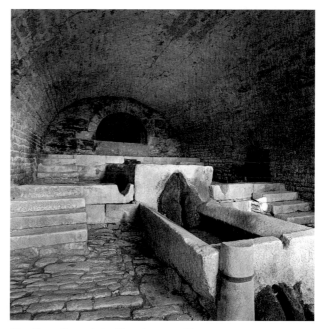

Blacy, Yonne, Burgundy, twelfth century, one of the oldest extant *lavoirs* in France

Among public buildings of the French rural heritage, the *lavoir*, or public washhouse, is the most discreet and humble; though often beautiful, it is seldom remarked upon. *Lavoirs* are austere in form, yet each is unique, possessing its own character. Their architecture reflects the basic need for shelter and flowing water, with local and regional variations deriving from the use of indigenous materials and building traditions. Synthesized in the words of Eugène-Emmanuel Viollet-le-Duc, "There is often more art in a *lavoir* showing off the sincere and judicious realization of a program than in certain sumptuous edifices whose only merit is to let one think: it must have cost very much."[1]

Lavoirs flourished from the seventeenth century until the early twentieth century, when running water and the invention of the boiler and the domestic washing machine made them obsolete. Today the *lavoir* is often considered an outmoded form of public infrastructure, a relic of another era, evocative of different, and for the most part undesirable, attitudes toward work, time, public life, and gender. Unusable and socially irrelevant, these buildings have faced abandonment, vandalism, decay, and destruction.

Lavoirs resonate with the sensorial and social dimensions of the laundresses' tasks, yet, unused and empty, they convey an impression of mystery and solitude, replete with ghosts and memories. Their interiors of curious beauty are often secreted behind anonymous building enclosures that filter daylight through their apertures to reflect off the water's surface. These simple facades hide three hundred years of women's social encounters, hard work, and spirited conversations. As a result of their simple functional requirements and their endurance through periods of intense political and social upheaval, the *lavoirs* reveal a dense history of building technology and formal symbolism.

WHITER THAN WHITE

The year of our lord 1821, the 26th of the reign of Louis-le-Désiré [Louis eighteenth], love, respect, thankfulness, to you, François Condamine, this beautiful lavoir was given to us by your munificence. —Saint-Martin-sur-Oreuse, Yonne

Lavoirs first appeared in seventeenth-century France in direct response to emerging health concerns. The lack of independent return-water systems had gradually polluted the country's waters through most urban watersheds. A succession of plague epidemics had ravaged the country from the 1450s to the 1560s, and warm water was thought to be responsible for opening pores and letting in illness. Growing fears of the ill effects of water had ended the popularity of public baths, associated with pleasure more than with cleanliness, and steam rooms, branded by the church as places of decadence and debauchery. A general fear of water prevailed for nearly three hundred years.

Public health became a prime political issue under the reign of Louis XIV (1643–1715), when a growing concern with cleanliness and health paradoxically coincided with the conception of water as dangerous. Wiping the body replaced washing, and cleanliness became a visual concept. Clothes were believed to absorb all of the skin's impurities; thus the whiter one's garments, the cleaner one appeared to be. Only underwear—made of serge, hemp, or the most expensive alternative, linen—could touch the skin, and it was changed more or less regularly, according to the wearer's social status. Cleanliness was thus associated not only with physical and moral well-being but also with wealth. Unlike underwear, outerwear did not necessitate washing, since it did not come in contact with skin. People's desire to expose clean white garments induced changes in fashion, such as excess underwear overflowing at the sleeves and collars to reveal one's shade of white.

The construction of *lavoirs* followed closely upon the cult of white linen. Architecturally significant examples were initially built for the elite on private property, generally within the vicinity of a château or a church. For the remaining rural populace riverfront platforms were adapted into vernacular *lavoirs*, few of which remain.

GOING PUBLIC By the end of the eighteenth century, the plague had become a distant memory, and a drastic shift in mentality advanced the virtues of water. With the cholera epidemic of 1832, water was given a new, purely beneficial, role; as air was now thought to be conducive to illness, it had to be cleaned, and this could only be done with water.[2] The entire infrastructure for the water system was reevaluated and took priority over monumental civic buildings. Issues of water distribution were coupled with concerns about its disposal, and streets were redesigned to accommodate water runoff in gutters.

As a consequence of unequal access to water, class distinctions were visually apparent, and cleanliness became emblematic of affluence. The 1849 cholera epidemic, which killed 20,000 Parisians, highlighted this disparity. It devastated the city's overcrowded center, the barricaded territory of the laboring classes, rather than the wealthy outlying neighborhoods with their emerging sanitation. As the concept of cleanliness evolved from a primarily visual phenomenon to one involving issues of health, a new word entered the French vocabulary: hygiene.

Following the coup d'état of 1851 and the beginning of the Second Empire, Baron Georges-Eugène Haussmann's engineer, Eugène Belgrand, configured an impressive water and sewer network system for Paris. Separate conduits divided washing water from potable water, and affordable public baths and free *lavoirs* appeared in every neighborhood. Similar improvements soon took place in the provinces after the government made the extraordinary sum of 600,000 francs available to provincial towns for the construction of public baths and *lavoirs*.

facing page top: An unassuming *lavoir*, Dionne, Côte-d'Or, Burgundy, nineteenth century

facing page bottom: Two *lavoirs* built as monumental civic buildings—Vaux-le-Moncelot, Haute-Saône, Franche-Comté, nineteenth century *(left)* and Frasne-le-Château, Haute-Saône, Franche-Comté, 1833 *(right)*

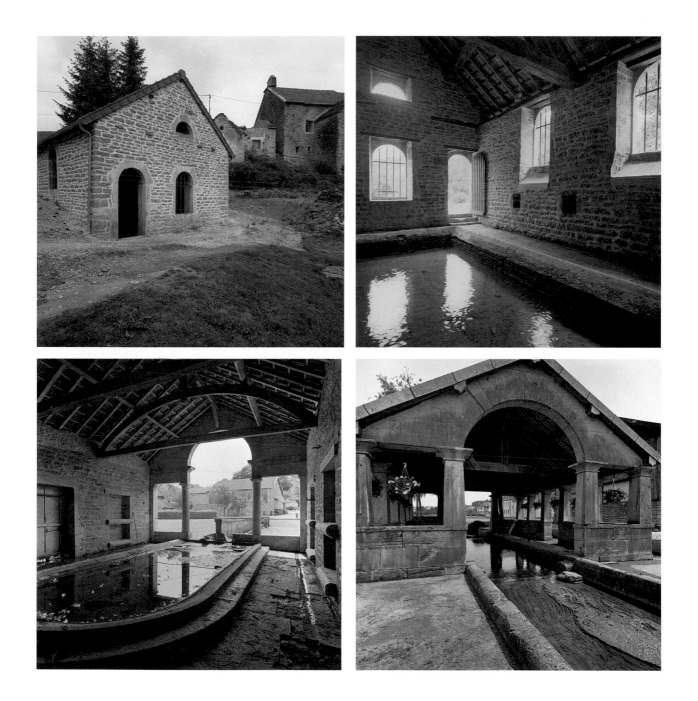

4

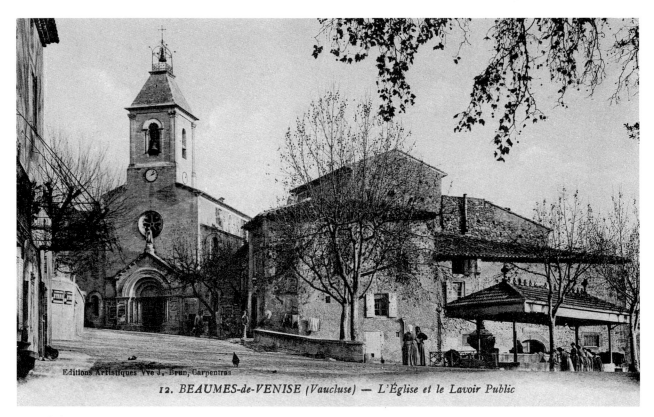

Postcard of a town center, Beaumes-de-Venise,
Vaucluse, Provence, nineteenth century

FROM STRUCTURE TO ARCHITECTURE

These waters were brought to Courson in 1847, under the administration of Mr. Bouillé, mayor. This lavoir was built in 1857 under the same administration, according to the plans of the architect Grégoire Roux. —Courson-les-Carrières, Yonne

In most French villages and small towns, there are few basic public buildings. The church, crowned by a steeple, is the most prominent early example. With the advent of the Republic, the town hall (*mairie*) and the community center (*salle-des-fêtes*) emerged, followed by the public school, the market hall, and the *lavoir*. The architecture of these minor public buildings was a direct reflection of the town's wealth. Thus, during the nineteenth century, the architecture of rural *lavoirs* shifted from minimal functional expression to symbolic embodiment of civic pride, represented in neoclassical form. Although the specific form of the *lavoir* varies according to site constraints, such as means of access to water, proximity to the town center, and availability of local materials, each embodies the general social and technological milieu in which it was created.

DOWN BY THE RIVER The first rural *lavoirs* were vernacular structures built directly on the river. The main design concern, particularly in the north of France, was to provide a shield against the cold. At Mereville (Essonne) the enclosure was maximized and the roof lowered to protect kneeling laborers, while daylight was optimized on the slanted stones to facilitate spotting stains. Although these early structures were generally outside of town and purely functional in form, an architect's hand was occasionally visible, as with the *lavoir* of Vanvey, built in 1824 according to the plans of Dijon architect Antoine Chaussier.

A primary factor in the *lavoir*'s form was the periodic shift in the river's water level. Designs that address this issue range from the purely architectural to the mechanically engineered. Architectural examples include the *lavoir* of Avigny (Côte-d'Or), which has a four-bay facade that steps up to the access door. As the river rises, the usable entry shifts from one bay to the next while portions of the interior become submerged. Construction of the *lavoir* of Voutenay-sur-Cure, built in 1827, involved banking the river and creating an artificial island on which to site the building. The river flows symmetrically to either side as well as through the structure, in which a double-stepped basin accommodates a range in water level.

Mechanical apparatuses are apparent in *lavoirs* scattered along the banks of the Eure, used by the tanning industries of Chartres (Eure-et-Loir). Adjustable platforms hung with chains or steel cables from a mechanism of winches and pulleys allow the working surface to be adjusted relative to the water level. This mechanism was often used to upgrade older structures, such as the *lavoir* of Mirebeau-sur-Bèze (Côte-d'Or), where the platform engineering was refitted in 1904.

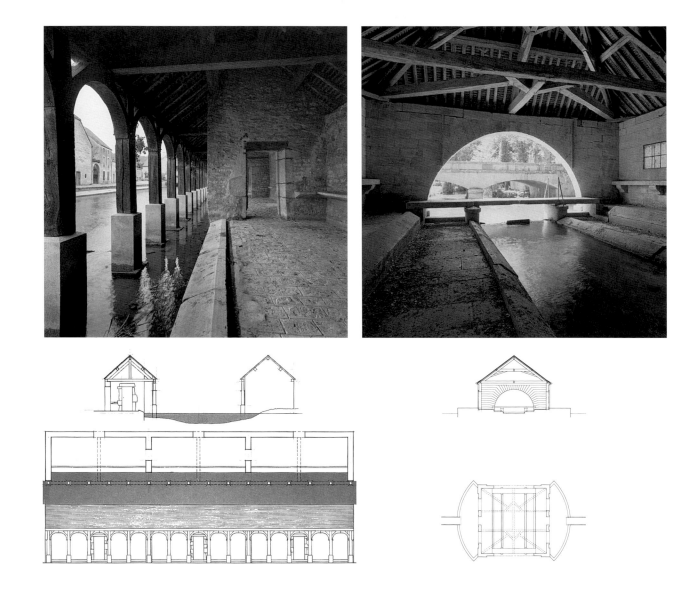

6

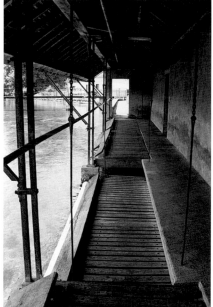

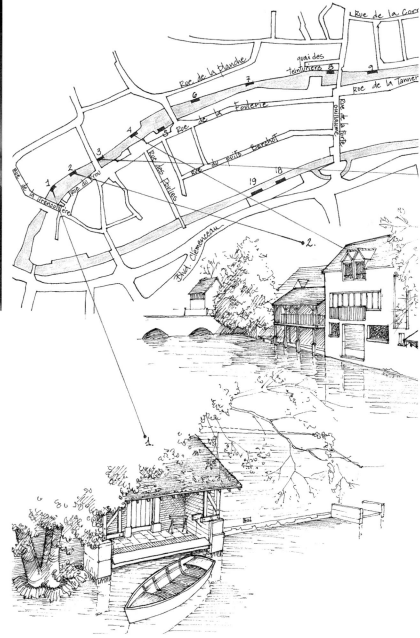

facing page left: Interior, section, plan, and elevation of Vanvey-sur-Ource, Côte-d'Or, Burgundy, 1824, architect: Antoine Chaussier

facing page right: Interior, section, and plan of Voutenay-sur-Cure, Yonne, Burgundy, 1827, architect: Tircuit

above: A mechanism of winches and pulleys upgraded this old *lavoir* at Mirabeau-sur-Bèze, Côte-d'Or, Burgundy, eighteenth century, updated 1904.

right: Mechanical apparatuses are apparent in *lavoirs* scattered along the banks of the Eure, in the town of Chartres, Eure-et-Loir, Centre.

GOING TO THE SOURCE Many hill towns lacking an adjacent river built *lavoirs* directly over a spring. These structures, often embedded in a hillside, are particularly prevalent in arid regions such as Provence and the lower Alps. Because their flowing water is fresh and pure, these *lavoirs* are often part of a complex that includes a potable-water fountain and trough. The course of water always follows the same hierarchy between tasks: drinking fountain, followed by trough, then by the washing basins. Cattle would always take upstream priority over the cleaning of laundry.

The vaulted space of each *lavoir* results from its urban site. Most hill towns of Provence are built on an infrastructure of vaulted retaining walls stepping down the south face of the mountain side. *Lavoirs* naturally occurred under one of the vaults, and several are located under the town square, reinforcing the justification of a vaulted structure due to the heavy loads it had to bear. *Lavoirs* were oriented to the south to allow for a cool, shaded space during the sweltering summer heat and a midday ray of sunlight during the winter months.

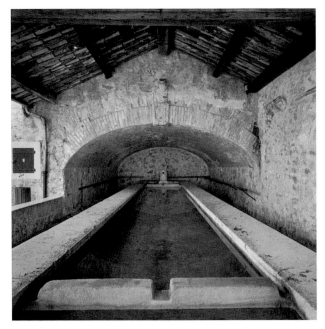

right top: A *lavoir* showing the typical course of water, Saint-Jeannet, Alpes-Maritimes, Provence, late nineteenth century

right bottom: A vaulted, urban *lavoir*. Sainte-Tulle, Alpes de Haute, Provence

facing page top: Lavoir with vaulted space, Barjol, Var, Provence, nineteenth century

facing page bottom: Lavoirs showing the terracing of urban space—plans and sections of Barjol, Var, Provence, nineteenth century *(left)* and Sainte-Tulle, Alpes de Haute, Provence, nineteenth century *(right)*

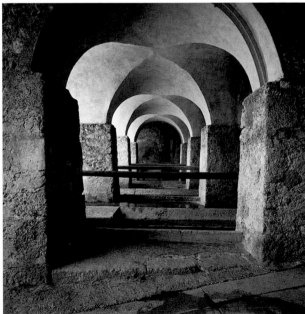

8

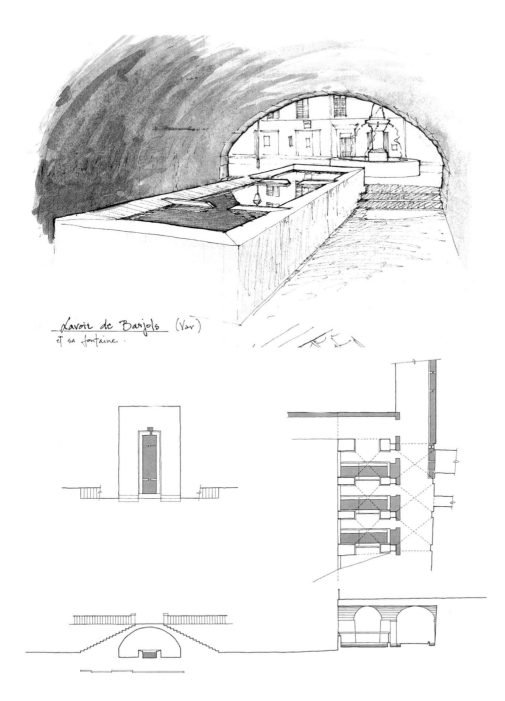

Lavoir de Barjols (Var)
et sa fontaine.

10

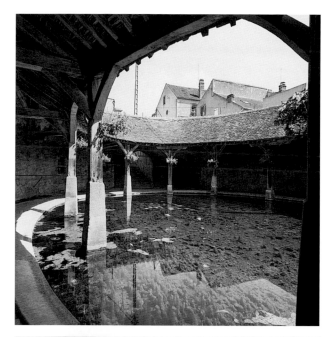

DOING LAUNDRY BELOW GRADE In towns lacking a nearby spring or stream, *lavoirs* were excavated from the ground and laundresses traveled down to the level of the water table. Because these could be as deep as fifteen feet, limiting access to natural light, such *lavoirs* often include an impluvium roof. The open segment of the roof admits natural light; its slanted sides protect the laundresses from winds and rain while collecting rainwater and directing it into the circulation system. Many of these subsurface *lavoirs*, such as those at Brienon-sur-Armançon and Tonnerre (Yonne), are almost invisible from the street, except for their rooftops emerging from the ground. These austere windowless *lavoirs* have spacious, brightly lit courtyards lined with colonnades that surround shimmering central water basins, and cloisterlike circulation around their perimeter. Their interiors are reminiscent of western India's stepwells and other inhabitable wells, such as Orvieto's Pozzo di San Patrizio.

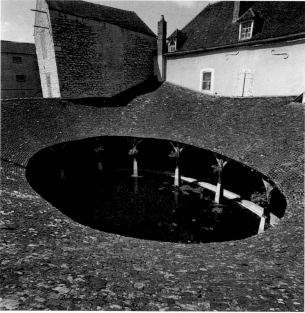

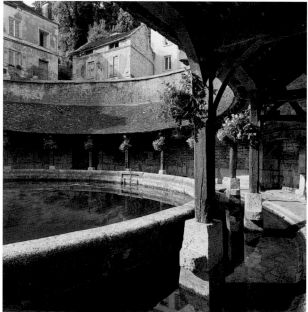

FREESTANDING LAVOIRS When engineers devised new systems for pumping and channeling water, the *lavoir* became independent of natural water sources. Once flowing water could be achieved in any location, a broader range of forms was possible; these were no longer conditioned by site constraints but responded to broader social needs. As the *lavoir* came to reflect a town's modernity, its wealth, and the cleanliness of its citizens, its external form became increasingly independent of its interior. Function was expressed on the interior, and symbolism on the facade.

Following the discovery of Pompeii's ruins in 1748, Parisian architects developed a penchant for templelike structures and neoclassical ornament. Provincial architects, eager to follow Parisian fashion but short on monumental commissions, found an appropriate venue for this formal expression in the *lavoir*. Beginning in the eighteenth century, architects were regularly entrusted with civil engineering projects, due to the royal administration's endorsement of the profession to supervise provincial expenditures on public works.[3] By 1820 communal resources, which had been mobilized under the First Empire for the Napoleonic campaigns, were reallocated for infrastructural improvements, and new *lavoirs* supervised by architects appeared throughout the country.

Lavoir-temples first appeared in the Franche-Comté, where Claude-Nicolas Ledoux designed bridges, roads, fountains, and troughs, in addition to *lavoirs*. Here he introduced a formal sensibility rarely found in such rural locales, thereby raising architectural standards throughout the region. Healthy rivalries soon arose among neighboring communes, and *lavoirs* became prime manifestations of the towns' sophistication and wealth. As a result, the most remarkable *lavoirs* are found in clusters, which are especially dense in the Franche-Comté region, specifically in the Haute-Saône, a department made rich by exploiting its dense forests for wood production. Architects of the Haute-Saône were particularly fond of the Palladian Serlian motif. Other regions of exuberant *lavoir* architecture and equivalent wealth are the wine valleys, specifically the departments of the Yonne and Côte-d'Or in Burgundy, as well as the valley of the Gironde near Bordeaux.

In the south of France, freestanding *lavoirs* maintained a lower profile and retained much of their vernacular character. The Midi-Pyrénées, Languedoc, and Provence were not prosperous wine-producing regions at the time, and their warmer climate did not necessitate enclosing the *lavoir*, which often consisted only of a simple water basin occasionally sheltered by a freestanding roof. These *lavoirs* are autonomous open-air pavilions rather than buildings. They offer protection from sun or rain but not wind. Subsequently, a wall was often erected between columns on the side facing the prevailing winds. In the valley of the Rhône, most *lavoirs* are closed to the north because of the Mistral, a strong and cold local wind coming down from the Alps. By thus exposing the laundresses to public view, the southern *lavoir* renounced the sober civic aura of the Franche-Comté model in favor of the visible reality of working-class women with their crude vocabulary and penchant for gossip. Nevertheless, the sight of the structure's stones impressed by centuries of demanding physical work commands an admiration and respect worthy of architectural monuments.

facing page:

top left: Etuz, Haute-Saône, Franche-Comté, 1845

bottom left: Plans and sections of Bourg-Saint-Andéol, Ardèche, Rhône-Alpes, 1844 *(left)* and Etuz *(right)*

top right: Fondremand, Haute-Saône, Franche-Comté, 1830, architect: Duret

bottom right: Plans and sections of Fondremand *(left)* and Soirans, Côte-d'Or, Burgundy, 1836 *(right)*

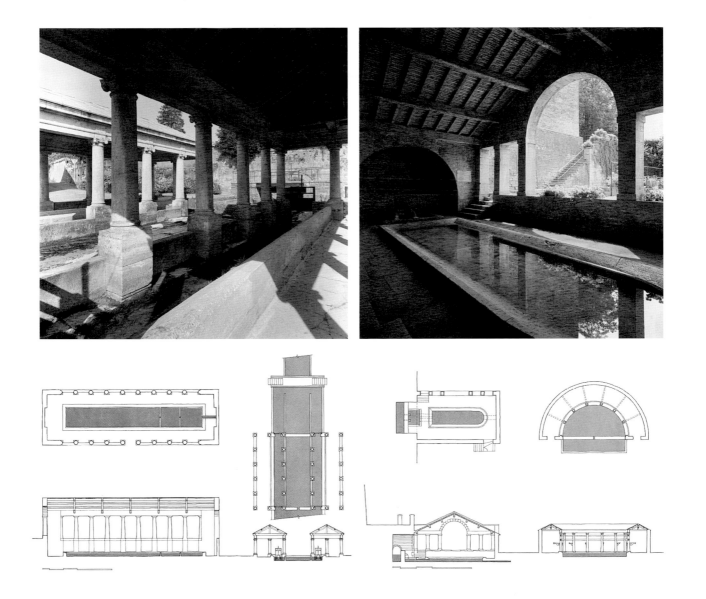

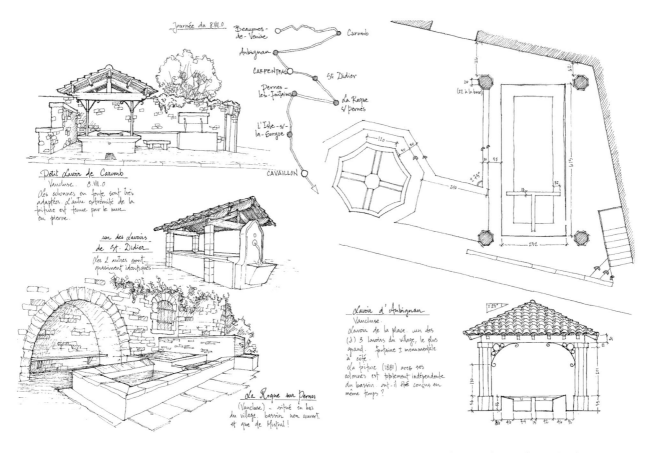

Journée du 8.VII.0

Beaumes-de-Venise — Caromb
Aubignan
CARPENTRAS — St Didier
Pernes-les-Fontaines — La Roque s/ Pernes
L'Isle-s/-la-Sorgue
CAVAILLON

Petit Lavoir de Caromb
Vaucluse. 8.VII.0
Des colonnes en fonte sont très adaptées. L'autre extrémité de la toiture est fermée par le mur en pierre.

un des lavoirs de St Didier
Les 2 autres sont quasiment identiques

La Roque sur Pernes
(Vaucluse) - situé en bas du village. bassin non couvert et que de Mistral !

Lavoir d'Aubignan
Vaucluse
Lavoir de la place. un des (2) 3 lavoirs du village, le plus grand. fontaine I monumentale à côté.
La toiture (1881) avec ses colonnes est totalement indépendante du bassin ont-il été conçus en même temps ?

14

In the south of France, freestanding *lavoirs* maintained a lower profile and retained much of their vernacular character. Aubignan, Vaucluse, Provence, 1881.

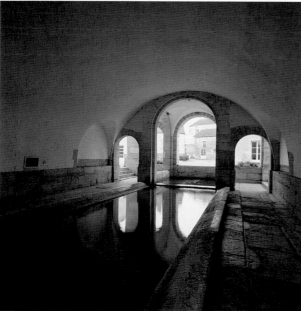

FUSION BUILDINGS The expense of constructing *lavoirs* often taxed a village's limited resources, and so a range of dual-function buildings emerged. The most common is the *lavoir-mairie*, which combines the two most prevalent civic building programs, *lavoir* and city hall, into a single structure. *Lavoir-mairies* are found extensively throughout Burgundy, and there are several in Franche-Comté. This unlikely combination compensated for the lack of respect given to habitués of the *lavoir* by providing villagers with a structure that reflected greater civic pride. It also provided the governing body of a town with an unrivaled edifice, a sensitive issue in villages where the architecture of the *lavoir* often surpassed that of structures used by more esteemed villagers.

This political strategy had variants to please different groups, and throughout the country various public functions were paired with the *lavoir* under a common roof. In Sennevoy-le-Haut the *lavoir* is built under the community center. The town of Reulle-Vergy (Côte-d'Or) housed communal archives above the *lavoir*, while in Sœuvres (Yonne) and Dissangis (Yonne), it is paired with the public

left: Lavoir-mairie, Dampierre-sur-Salon, Haute-Saône, Franche-Comté, 1828

below: Plans and sections of *lavoirs-mairie* in Bucey-lès-Gy, Haute-Saône, Franche-Comté, 1827, architect: Louis Moreau *(left)* and Cromary, Haute Saône, Franche-Comté, 1870 *(right)*

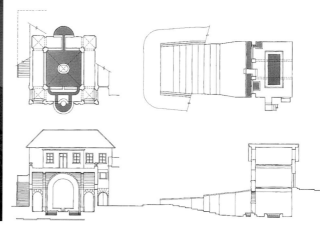

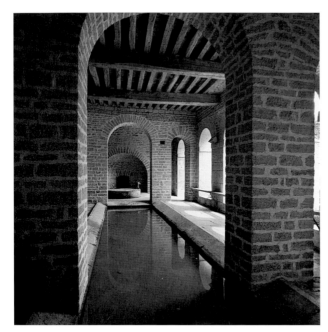

school. In Le Cordonnet (Haute-Saône), the plans for the *lavoir* designed in 1826 included upstairs quarters for the village school teacher. Due to financial constraints, the *lavoir* was built as a single-story structure only.[4] The beautiful complex of Jaugey (Côte-d'Or) combines a fountain with a two-basin *lavoir* framing a chapel to Saint-Fiacre. The gurgling of flowing water mixes melodiously with the sound of the bell crowning the campanile, making this elegant edifice an unusual union.

Today public functions such as those of the post office or office of tourism might occupy the upper level of a *lavoir*—if not the space of the *lavoir* itself—although it is clear that such spaces were originally intended for different public uses. Even private residences occasionally exist above *lavoirs*, with multiple examples in the town of Chartres (Eure-et-Loir).

left: Lavoir-salle communale, Sennevoy-le-Haut, Yonne, Burgundy, 1828

right: Lavoir-mairie, Dissangis, Yonne, Burgundy, 1833, architect: Tircuit

LAUNDRY DAYS

It is not permitted to use the beater or to hold loud conversations from 8 PM to 7 AM. —Vence, Alpes-Maritimes

The monumental facades of the Franche-Comté *lavoirs*, with their classical proportions and public arcades, reflect the aspirations of those who facilitated their construction: civic leaders, architects, engineers, and workers—most likely all men. These dignified exteriors contrast with the soft, dark, humid spaces of the interiors that constitute the women's sphere. The following sections attempt to revive the atmosphere of the old *lavoir*, a dynamic social place that mirrored the perfidious complexities of life, accentuating the contrast with today's empty, silent space that only reflects inverted images in the water's too stagnant surface.

RITUAL The evolution of the *lavoir* closely followed changes in laundering practices. *Lavoirs* were originally used only for rinsing during a biannual community event, performed over the course of three days, referred to as the *buées*, or *bugades* in Provence. On the first day, called "purgatory," storage closets were cleared of six-months worth of linens, sheets, and shirts—mostly whites. These piles of soiled laundry, kept in humidity-free oak armoires or attic granaries throughout the year, were soaked at home in basins filled with water for an entire day to loosen the rough stains and grease. During that time, women collected firewood and ashes to be used the following day.

On the second day, referred to as "hell," the women sorted the linens and carefully layered them in large pine basins mounted on tripods, at the bottom of which were placed herbs with bleaching properties. Depending upon the region, or the individual woman's family secrets, these herbs or other organic matters varied from vine shoots to chopped iris rhizomes to nettle. Saponin and crushed egg shells were especially known for their whitening properties, while sweet clover served as moth repellent. In Provence, thyme, fennel, or lavender (Latin: *lavere*—to wash) were also used to perfume the laundry. A heavy sheet covered the basin, and ashes made of freshly cut wood were spread on top. Such ashes contained a high concentration of potassium carbonate, or potash, an effective cleansing agent. Boiling water was then poured over the ashes, and it slowly filtered through the many layers before trickling out from a small aperture at the bottom of the basin. The water was then collected, reheated, and poured back on top. This cycle was repeated many times over the course of the day.

The third day, "Heaven," reflected a balance between hard work and social pleasures. It began with the women gathering to march down to the *lavoir*, carrying heavy loads of wet laundry in wheelbarrows and in bundles on their heads. This final day at the *lavoir* concluded with feasting on baskets of food and alcohol in the presence of the young children who accompanied their mothers. At the *lavoir*, often a mile or two out of town, women knelt down in their *carrosse* or *auget*, a personal wooden box with a carpeted bottom, that protected them from the spattering of water and the hard surface of the ground. They washed off the ashes that had absorbed the grease with soap, then clobbered the fibers of the laundry in the water with a wooden beater until all remains of soapy water were removed. The loads were then hung to dry either on the lines provided in the *lavoirs* or on sawhorses brought for the occasion, or spread on the surrounding bushes and lawns, where sunlight would contribute to the bleaching of whites. Each family aimed to cover the greatest surface with linen; this display was a source of pride for the rich villagers. During the eighteenth and especially nineteenth centuries, linen was considered a capital asset. Brides' dowries consisted mostly of a collection of embroidered sheets, tablecloths, napkins, and towels assembled to last the newlyweds' lifetime. During the eighteenth century, the theft of linens met severe punishment because it infringed on the notion of public faith, and a person caught stealing could be subjected to public beating or shackles.[5]

The traditional *buées* occurred twice a year, at the beginnings of spring and autumn. The less fortunate classes and mothers of young children were obliged to do laundry on a more frequent basis. The increased frequency of the practice of washing prompted laundresses to petition town officials for the construction of *lavoirs* in each neighborhood. Once the *lavoir* had to be shared on a daily basis, the traditional schedule of the *buées* was abandoned.

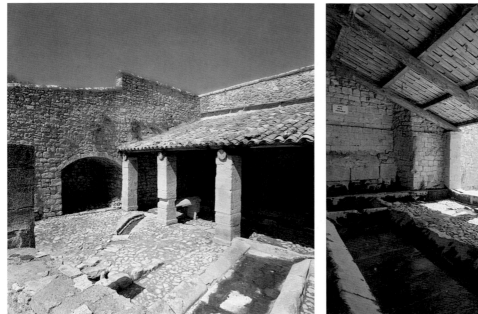
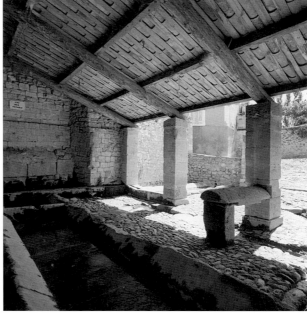

18

above: Lavoir de la Bonne Fontaine, Forcalquier, Alpes de Haute-Provence, Provence, seventeenth century

right: Saint-Chamas, Bouches-du-Rhône, Provence, seventeenth century

facing page: Interior, plan, and perspective of Bourogne, Territoire de Belfort, Franche-Comté, nineteenth century

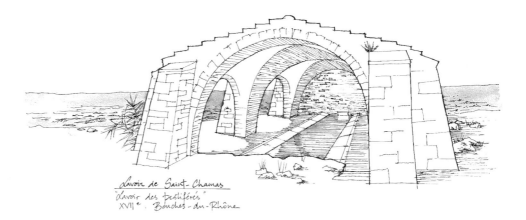

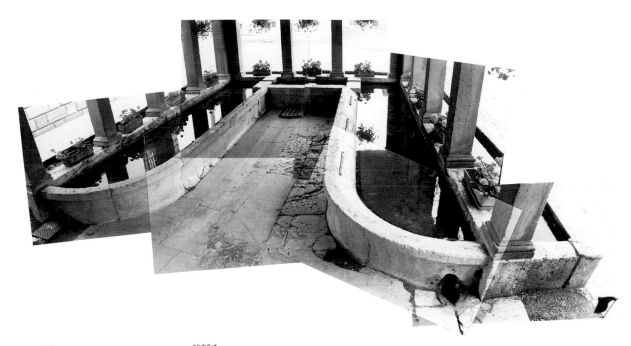

19

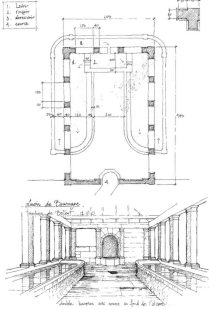

DIVISION OF LABOR Advances in cleaning products and the development of affordable soap allowed for the washing and rinsing cycles to occur in a single day at the *lavoir*. Basins were thus divided to allow for simultaneous washing and rinsing. A hierarchy of placement was instilled along the length of the *lavoir*, with the rinsing basin always being upstream from all others. The water would then flow into the washing basin, where whites were given priority over colors, generally pushed farther downstream. Next came garments with menstrual blood, followed by cloth diapers, and finally the clothes of the sick, though these were generally outlawed from the public *lavoir*. In many villages, such as in Saint-Michel-l'Observatoire (Alpes de Haute-Provence), a sign hung in the main *lavoir* says, "Notice: washing the linen of the ill will be punishable by fine." Down the road, and downstream, another *lavoir* bears the following words stenciled on the wall: "*Lavoir* reserved for contagious diseases." In the nearby town of Forcalquier, a grave incident occurred in 1478, after a woman washed the clothes of her husband, who died from the plague, at the *lavoir* de la Bonne Fontaine. The

disease contaminated women who came to wash sheets, further spreading the epidemic. The town council had to intervene, ordering a complete draining of the basins.[6]

The *lavoir* of Saint-Chamas (Bouches-du-Rhône) is as far downstream as possible. Built on the bank of the Etang de Berre on the Mediterranean, its waters pour directly out on the beach. It is commonly referred to as the *lavoir des pestiférés*, reserved for linens that have been exposed to leprosy or the plague.

In most *lavoirs*, the privileged places upstream were highly coveted, and women would need to wake up early to reserve their spot there. All other users would inevitably be washing in gray water. In the town of Les Milles (Bouches-du-Rhône) near Aix-en-Provence, the architect included lanterns, suspended from the roof structure, which prolonged the use of the *lavoir* from the crack of dawn well into the evening, accommodating a high turnover of users. In most centralized locations, however, the laundresses were not allowed to disturb the silence of the night. Basins would be cleaned on Sundays only, providing ideal working conditions to only one washerwoman, one day a week.

One interesting solution to the high demand for upstream positions can be seen in the multibasin *lavoirs* of Provence. The flow of water is divided into parallel circuits, each accommodating a rinsing and a washing basin—thus multiplying the desirable spots—before merging back together in the return water canalization. Another solution based on the same principle is to divide the length of the longitudinal basin into two symmetrical halves. The flow of water either emerges from the center and flows out toward each end, as in Bourogne (Territoire de Belfort, Franche-Comté) or is channeled to each extremity and flows down through pairs of rinsing and washing basins into a common central drain, as exemplified in the *lavoir* of Aups (Var) *(see color plate 2)*.

IMPROVED STANDARDS The *lavoir*'s daily usage prompted transformations and ameliorations in its mechanics. Owing to the increased manipulation of water levels, basins could be raised from the ground to a more ergonomic height, relieving users of backaches and early arthritis. As new *lavoirs* were built, additional components were adapted to preexisting forms, remediating existing inconveniences. When possible, fireplaces were included in a corner to heat up cauldrons of hot water to mix with the cold running water, and to provide the *lavoir* with much-needed warmth during the winter. Occasionally, an enclosed bathroom can be found in a corner, although these probably were added during the early twentieth century.

To accommodate weekly cleanings of the basins necessitated by increased deposits from soap-saturated water, drainage systems were devised to allow for partial use of the *lavoir* during the cleaning. While the washing basins were drained and brushed, the rinsing basins were used as soaping sinks, until it was their turn to be cleared and scrubbed. Overflow drains and an adjustable lock helped to maintain a stable water level. A drainage groove toward the bottom of the slanted washboard stone caught the foam created on the water's surface, while leveled portions of the stone were used to hold soaps, preventing them from slipping into the water. The need for drying bars prompted a wide range of creative solutions that enhanced regional differences and displayed the skills of local tradesmen such as the metalsmiths. The small *lavoir* of Les Godards (Nièvre) in Burgundy presents an exceptional example of ironwork.

In the medium-sized towns equipped with at least two washhouses, the issue of crowdedness resulted in the privatization of some *lavoirs*. Using the public *lavoir* implied either quarrels over the best spots and soap-saturated water, or an early morning arrival. Occasionally, women deposited their *auget* on the ground the day before in lieu of a reservation, but signs such as in the *lavoir* of Saint-Cannat (Bouches-du-Rhône) warned against the practice of reserving places. In the private *lavoirs*, women paid a fare per day and worked under the supervision of a head laundress who regulated placement and oversaw serious disputes. Although a strong solidarity generally existed among the *lavandières*, squabbling was an inevitable part of the day. Whether public or private, the life at the *lavoir* was always colored by the different types of women who used it.

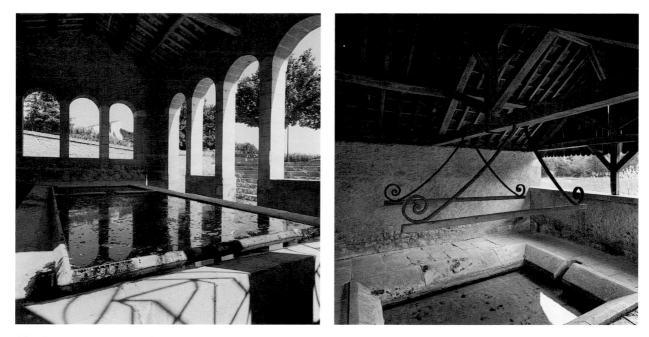

left: A drainage groove catches the foam at Fontarèches, Gard, Languedoc-Roussillon, nineteenth century

right: Les Godards, Nièvre, Burgundy, nineteenth century

LAUNDRESSES

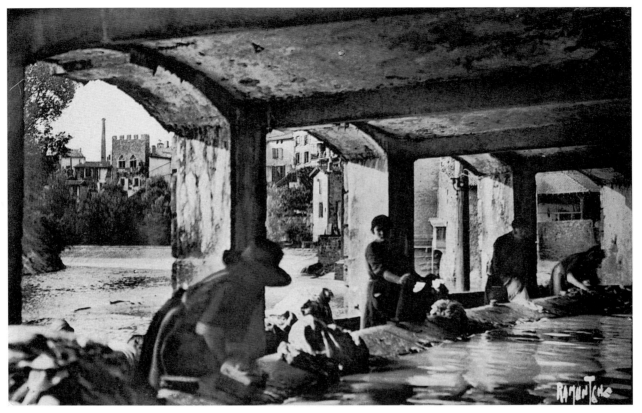

Do not complain about your husbands, all dirty laundry is not being washed here. The beater serves better here than the blather. Friendliness and honesty is worth more than spoiled beauty. —Saint-Maurice-Montcouronne, Essonne

The story of the washerwomen—the *laveuses* or *lavandières*—is worth telling, although understanding these women's lives, beyond a superficial description of their reputation, is difficult. Three different types of women met at the *lavoir*: the professional laundresses commissioned by the bourgeois families, individual housekeepers who could not afford to have their laundry done by someone else, and housewives who for a charge took neighbors' or merchants' garments along with their own. Proper bourgeois women did not use

the *lavoirs*, and it was not appropriate for a young girl of a good family to come within its vicinity. The professional laundress benefited from a privileged status at the *lavoir* and often was assigned a reserved spot upstream, which heightened the tension with the other users, engendering the type of quarrels for which *lavoirs* are notorious. Rather than ascribe the common negative connotations to the *lavandières*, it seems more constructive to understand the source and development of their poor reputation.

above: Laundresses at Mont-de-Marsan, Landes, Aquitaine, nineteenth century

facing page: Mont-de-Marsan today

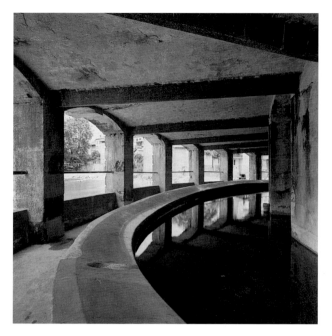

CLEAN CLOTHES AND SOILED REPUTATIONS

The village laundress was at the very core of the life and death cycle: at each birth, she assisted the midwife, cleaning and purifying linens and the newborn they enveloped. After a death in the village, she cleaned the body, washed the clothes, and prepared the shroud. Both functions too often collided into one dreaded event: stillborn babies and mothers dying in giving birth were common in France until the twentieth century.

White was symbolic in funerary rituals: it facilitated the soul's cleansing of its sins. Souls were believed to appropriate the purity of the white pieces, whereas the mourning entourage would wear black to protect themselves from the souls.[7] The use of the *lavoir* was prohibited on certain days, such as the week between Christmas and New Year's Day, the Holy Week, and the "octave of the dead" (now reduced to All Soul's Day) on November 2, because of the believed presence of souls on Earth on these days. Souls were thought to purify themselves in open bodies of water functioning as purgatories. The term "purgatory," which designates the

process of soaking during the first day of the *buée*, found its origin in this belief.

Although the character traits that define the quintessential *lavandière*—strong, invulnerable, hardened, but cheerful all the same—originated from the demanding involvement of these early functions; laundresses ceased to customarily help with the rituals of births and death as the task of doing laundry became a full-time profession. In addition, this early practice of cleaning bodies within the privacy of homes diminished the boundaries between upper and lower classes, and heightened the villagers' sense of the laundresses' intimate invasion. This uneasiness only amplified when they were trusted with the town's laundries.

Lavandières were said to "read" clothes, underwear, and sheets, compiling information as their main fortune. Known for their uncensored gossip and feared for their knowledge of the townspeople's intimate lives, these women held considerable power among the local populace. Legends depicting them as crazy witches express a collective need to destroy their credibility. But even if they did not have the respect of the bourgeoisie, the *lavandières* enjoyed a deep sense of community. When needed, they would hasten to one another's side, and they knew when discretion was necessary. For a young woman in trouble, the *lavoir* was the first place to go in quest of solidarity, advice, and moral support since laundresses knew social marginality.[8]

Life at the *lavoir* was bustling with activity and noise. The loudness of the often-vaulted space, saturated in the white noise of flowing water and punctuated by the beating of laundry, led to high-volume conversations. The space of the *lavoir* has been compared to a woman's version of the café, where men engaged in animated discussions on local politics and village life. Implicitly, the comparison ignores men's lack of physical effort while sipping pastis. But no such social gathering space was available to women without an associated domestic function. The *lavoir* represented a uniquely feminine space of relative emancipation. Women vociferously argued over the latest elections, the loss of tradition to modern conveniences, or local issues. Engraved in the stone walls of the lavoir of Barbirey-sur-Ouche (Côte-d'Or), a welcoming phrase reads, "Good morning

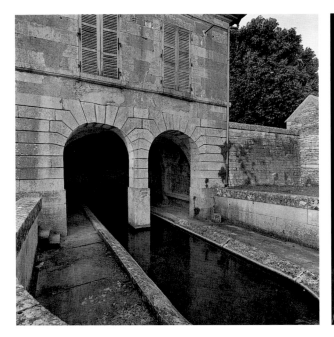

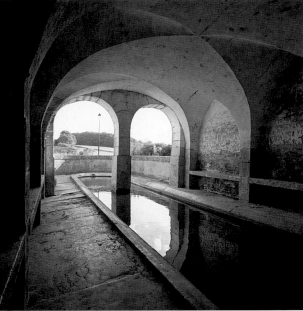

24

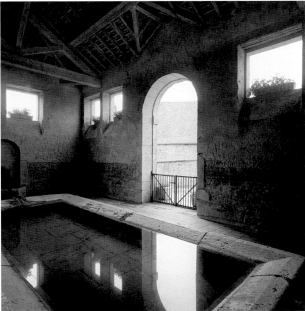

above: A *lavoir* built under the city hall. Lavoir-Mairie, Civry-sur-Serein, Yonne, Burgundy, 1864

right: Barbirey-sur-Ouche, Côte-d'Or, Burgundy, 1863

facing page: A *lavandière* at work

blabbermouths." Village men were not welcome in the vicinity of the *lavoir*; to pass a message to their spouse, they would have to signal from a distance. References to unsolicited visitors being thrown in the basin are common in the oral histories of villages.

A variety of pauses gave rhythm to the *lavandières'* long day of work: ambulatory merchants brought coffee and pastries to the working women, and wine and grogs were commonly served during afternoon pauses, especially in winter. Fortune tellers also interrupted laundry days, reading the oracle in the flotation patterns of linens or in the more traditional tarot cards. On an almost daily basis, traveling musicians came to the *lavoirs*, main destinations on their route, to sing the latest tunes being played in the city. Laundresses eagerly left their task at hand and indulged in the pleasure of dancing while learning the popular refrains.[9] Young children supervised by the laundresses were often witnesses to the life at the *lavoir*.

Such a unified community of women was often alarming to the men of the town. It was suspected that decisions were first envisioned at the *lavoir*, then brought to the privacy of each household where they were infiltrated into the collective consciousness of the voting gender. Town leaders desirous of control saw the *lavandières* as a threat, and so sought to geographically centralize the *lavoir* in order to gain supervision of them. The *lavoirs* built under the city hall are an ultimate manifestation of this concern. On the other hand, bourgeois women were eager to maintain the *lavoir* as distant from the town center as possible. One petition condemned the anticipated construction of a *lavoir* within the vicinity of a school in light of the improper language that the children would hear.[10]

Quarrels between laundresses often turned into serious confrontations culminating in physical brawls using clothes beaters. In *L'Assommoir*, which tells of the rise and downfall of laundress Gervaise Macquart, Emile Zola describes in thorough details the daily life of the *lavoir*, including beatings and forced immersions. The vocabulary and manners of laundresses on the defensive is legendary. When short on vile insults, they reportedly lifted their skirts and showed off their behinds. Such anecdotes, while inflated confabulations,

encouraged bourgeois mothers to prohibit their children from going to the *lavoir*, where, rumor had it, boys could make an early entrance into manhood.

The life of the *lavoir* remains active in the memories of many French villagers, and mention of the *lavandières* is still part of everyday expressions and stories. Among the rural populace, the *lavoir* is likely to invoke taboo connotations of the *lavandières* rather than appreciation of its architectural merits. These associations might explain why so little effort has been made toward their preservation. As Diane Ghirardo argues of such structures:

"We must uncover spaces, spatial practices, and histories that concern women above all, with the argument . . . that through social practice, spaces are both configured and acquire meaning. . . . Such a historical approach allows us to recover histories not only of some exceptional buildings, but also, insofar as possible, structures and histories that have not been preserved precisely because of their associations with women."[11]

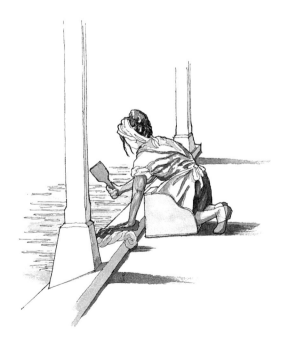

PRESERVATION OF RURAL PATRIMONY

Place of defamation and calumny—graffiti, Viviers-le-Gras, Vosges

Most remaining *lavoirs* are in remote villages that have seen little new construction in recent decades; those in larger towns and cities were destroyed because they were deemed to waste valuable public land. The *lavoirs* illustrated here were found in extremely small and isolated villages. Most are unused, although many constitute the village's most significant building. They are rarely seen or visited by anyone except the local inhabitants upon whose care and maintenance they depend. They require a minimal level of maintenance, such as removing branches or leaves from the water conduits to prevent flooding, and this is usually provided by a local resident.

What is to become of these water structures? In creating the Commission of Historic Monuments under Louis-Philippe in 1830, Prime Minister François Guizot sought to preserve representative examples of French architecture. The commission's original goals were not only to insure preservation of every monument the inspectors deemed worthy, but also to catalog them. This inventory coincided with the first generation of travelers and tourists, which influenced the building types selected: civic monuments, churches, and abbeys dating from Roman to medieval times. In 1960 Minister of Culture André Malraux began to include nonmonumental examples of patrimony, specifically the twentieth-century residential and institutional work of Le Corbusier and Auguste Perret in the list. In the mid-1980s debates between historians and ethnologists concerning the purpose of preservation prompted a shift in attention from monumental masterpieces to buildings reflecting broader social values. *Lavoirs*, windmills, and other threatened building types began to acquire official merit as witnesses to lost customs. During this period, some of the most significant neoclassical *lavoirs* became historic monuments, such as the *lavoir* of Argenteuil-sur-Armançon (Yonne).

There are both advantages and disadvantages to the designation "*monument historique.*" Once a building is so classified, it cannot be destroyed. Neither can it be renovated or repaired until a commission led by an official *architecte des monuments historiques* has conferred its stamp of approval. The process of obtaining such coveted classification is arduous, but once it is accomplished, villagers who might be eager to contribute to the restoration of their local *lavoir* are no longer easily able to do so without following lengthy administrative procedures. *Lavoirs* classified as "*monuments historiques*" enter competition with significant architectural landmarks for the limited budgets of the state and region. Implementing such regulation two decades ago would have prevented the destruction of some beautiful *lavoirs*, as well as the mutilation of others through thoughtless conversions. Now that expert permission and state funds are required to make roof repairs, however, the result is often eternal existence rather than a healthy longevity, insured by local preservation associations.

However, very few *lavoirs* are classified as historic monuments. In the last decade, most have received some level of attention from their communities, ranging from decorative geraniums hung between their arcades to intensive masonry repairs, showing a general interest for more than glorified history. Others have been sold to individuals, and interesting cases of adaptive reuse have resulted, such as a café-bar, a pool hall, a communal hall, and even an art gallery, found in the *lavoir* of Mougins, an affluent village near Cannes.

Because the *lavoir* emerged under specific historical and geographical circumstances, it is a uniquely French institution, reflecting a particular moment in French history. Nevertheless, it should not be treated as a romanticized relic, nor should it be recycled thoughtlessly. Today's *lavoirs* are not always short of function: in many towns they are regularly filled with children playing in the water during the summer days, or serve as hideouts for teenagers to meet after school and share their first cigarette or romance. Occasionally, an older woman still appears with a load of laundry to rinse. Nevertheless, *lavoirs* have yet to lose their disrepute. The few remaining *lavoirs* around urban centers serve immigrant families and homeless persons. In these areas, their demolition can be seen as a means to keep social mortification out of the public eye. Ironically, as these public washhouses continue to accrue social and historical layers, their future will be increasingly more uncertain, but the stories will long outlive the last standing *lavoir* and will eventually remain only as legends.

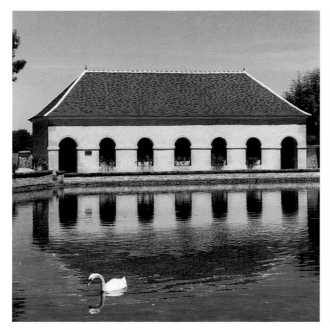

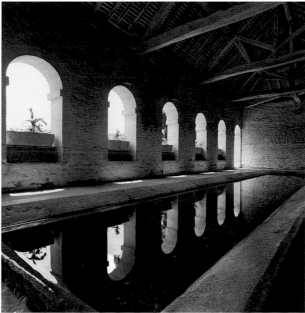

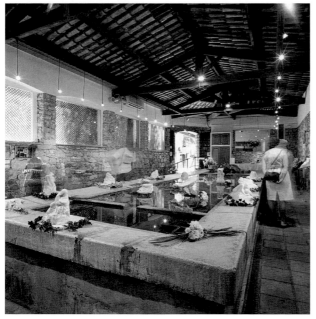

above: Argenteuil-sur-Armançon, Yonne, Burgundy, 1834, architect: Roguier. A plaque on this *lavoir* reads, "Excerpt from February 8th 1934 deliberation: The municipal council, considering this construction of public utility, given that the washerwomen are exposed to all seasonal weathers and often on rainy days, are drenched and frozen to the marrow, which leads to contagious and sometimes incurable diseases, put forward an opinion and a wish to plan the construction of an enclosed *lavoir*."

left: Mougins, Alpes-Maritimes, Provence, nineteenth century, now used as a gallery space

NOTES

1. Eugène-Emmanuel Viollet-le-Duc, quoted in Félix Narjoux, *L'architecture communale*, 1870, quoted in Christophe Lefébure, *La France des lavoirs* (Toulouse: Editions Privat, 1995), 138. (trans. by author)

2. George Vigarello, *Le propre et le sale: L'hygiène du corps depuis le Moyen Âge* (Paris: Éditions du Seuil, 1985), 164–168.

3. Denis Grisel, "Nymphées et fabriques: les fontaines monumentales des villages," *Vieilles Maisons Françaises* 105 (December 1984): 50–52.

4. Denis Grisel and Jean-Louis Langrognet, *Fontaines monumentales du pays des 7 rivières: Cantons de Rioz et Montbozon* (Langres: Société d'agriculture, lettres, sciences et arts de la Haute-Saône, 1998), 92.

5. Annick Couffy and Agnès Somers, *Mémoire de l'eau . . . Pélerinages oubliés* (Cergy Pontoise: Conseil general du Val d'Oise, 1991), 15.

6. Jean-Yves Royer, *Forcalquier* (Forcalquier: ODIM, 1986), 102.

7. Yvonne Verdier, *Façon de dire, façon de faire* (Paris: Éditions Gallimard NRF, 1979), 138–139.

8. The extraordinary play, *Le Lavoir*, set on August 2, 1914 and performed at the 1986 Avignon Festival, encapsulates the life of the washhouse through the thirteen women characters who inhabited it on the eve of World War I. Politics, ritual, town gossip, the passing of oral history, and the defamation of a young *lavandière* interweave into a beautifully crafted narration in Dominique Durvin and Hélène Prévost's *Le Lavoir*, in *L'Avant-scène théâtre* 795 (October 1986).

9. Michelle Perrot, "La ménagère dans l'espace parisien au XIXe siècle," *Les annales de la recherché urbaine* 9 (1981): 18.

10. Christophe Lefébure, *La France des lavoirs* (Toulouse: Éditions Privat, 1995), 48.

11. Diane Ghirardo, "Laundresses and Prostitutes in Renaissance Italy," in Diane Ghirardo, Barbara Allen, and Howard Smith, ed. *Diversity in Architectural History* (Boston: ACSA, 1996), 1.

PLATES

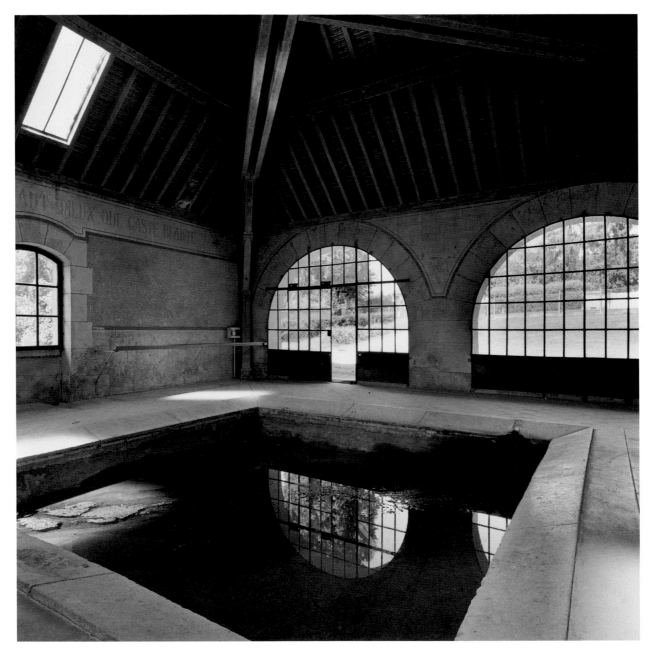

30

above: Lavoir Eudoxie Dervillé, Saint-Maurice-Montcouronne, Essonne, Ile-de-France, 1900

facing page: Lavoir de la Source, Ozouër-le-Voulgis, Seine-et-Marne, Ile-de-France, 1848, architect: M. F. Buval

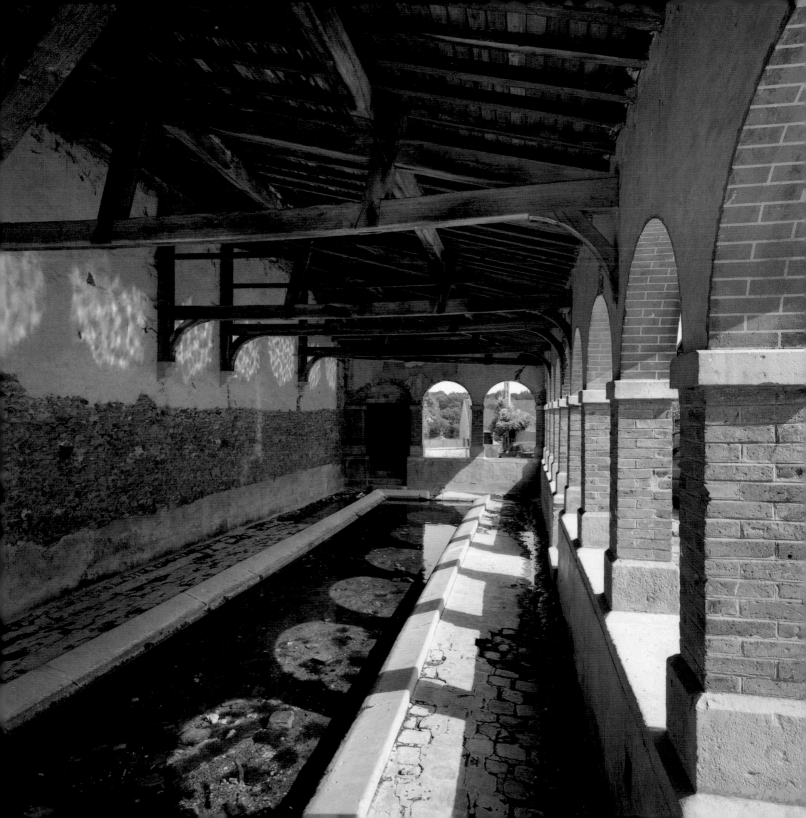

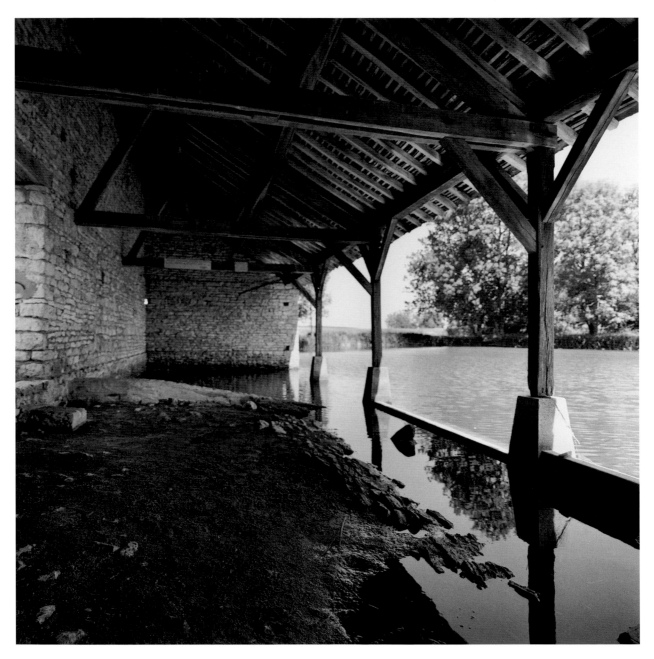

Avigny, Côte-d'Or, Burgundy, 1832

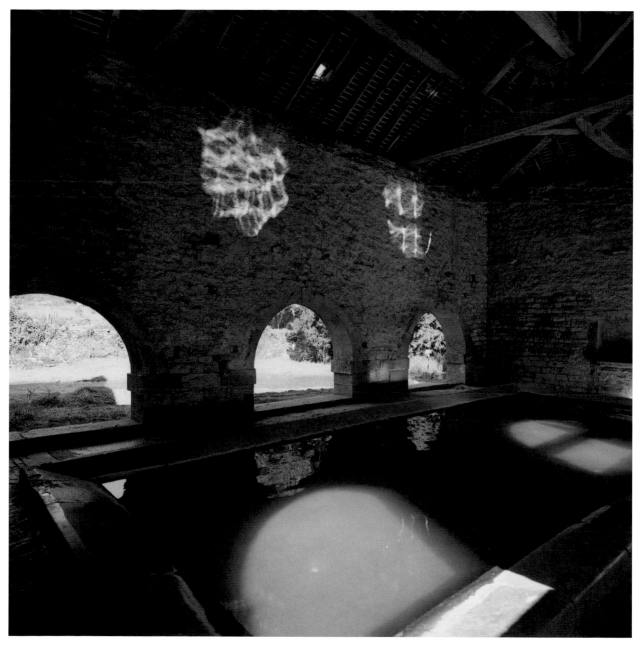

Bligny-sur-Ouche, Côte-d'Or, Burgundy, 1832

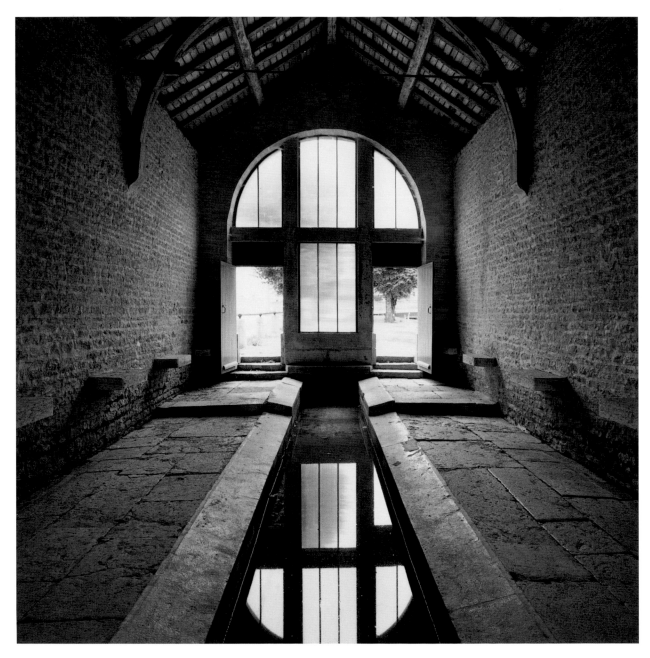

Brion-sur-Ource, Côte-d'Or, Burgundy, nineteenth century

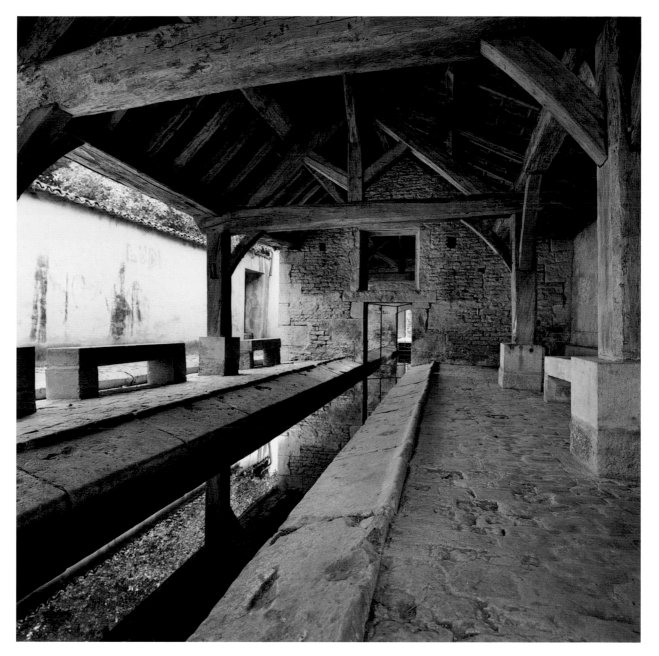

Lavoir de la Fontaine Boussambre, Chatillon-sur-Seine, Côte-d'Or, Burgundy, 1799, 1852 extension

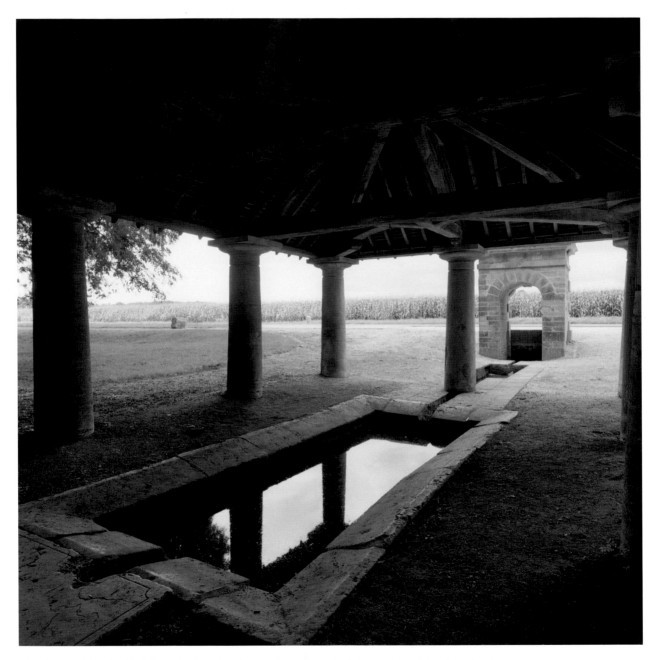

38

above: Lavoir de la Fontaine Henri IV, Fontaine-Française, Côte-d'Or, Burgundy, 1807. Note the recycled tombstone in the lower left.

facing page: Courban, Côte-d'Or, Burgundy, 1749. A recycled tombstone is used here at the threshold.

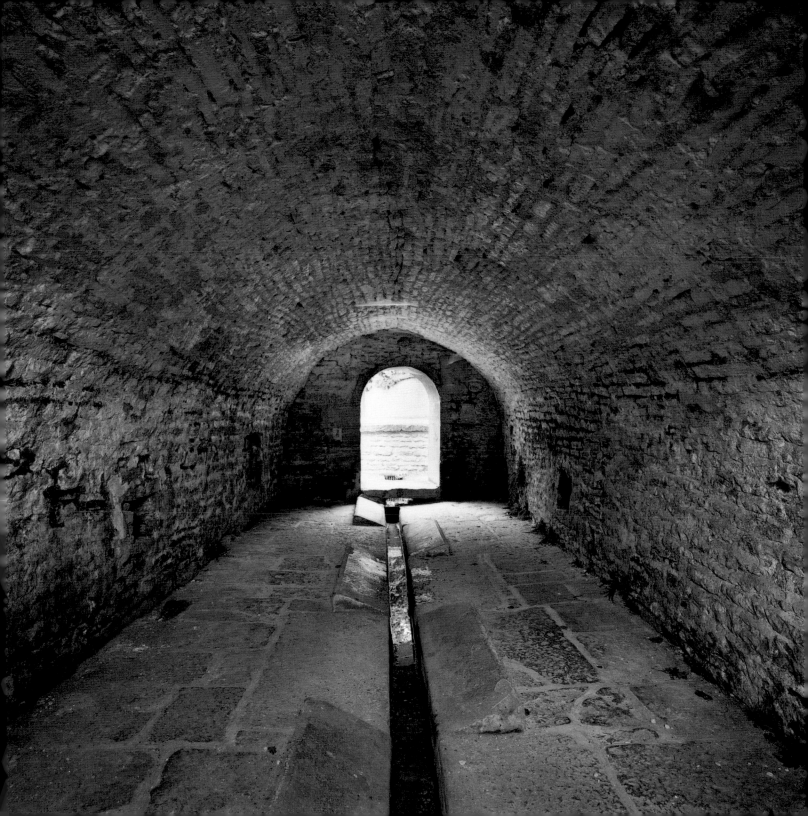

40

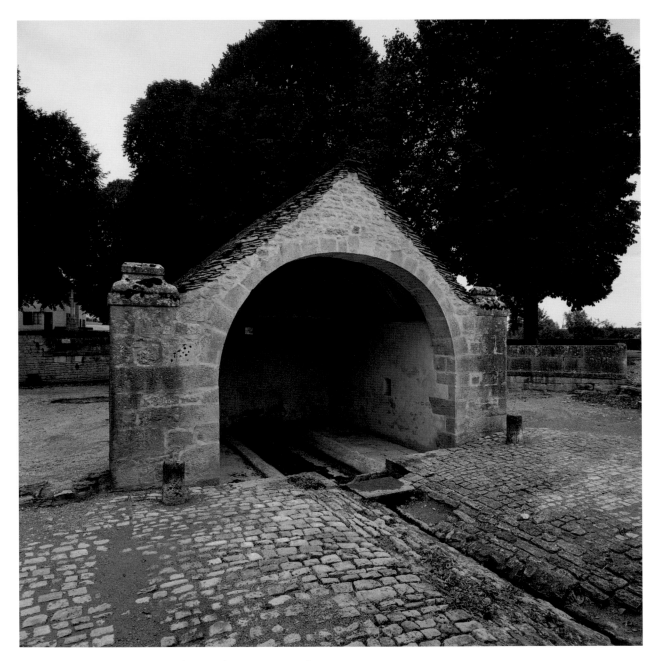

Fontaines-en-Duesmois, Côte-d'Or, Burgundy, 1781, architect: Pierre-Jean Guillemot

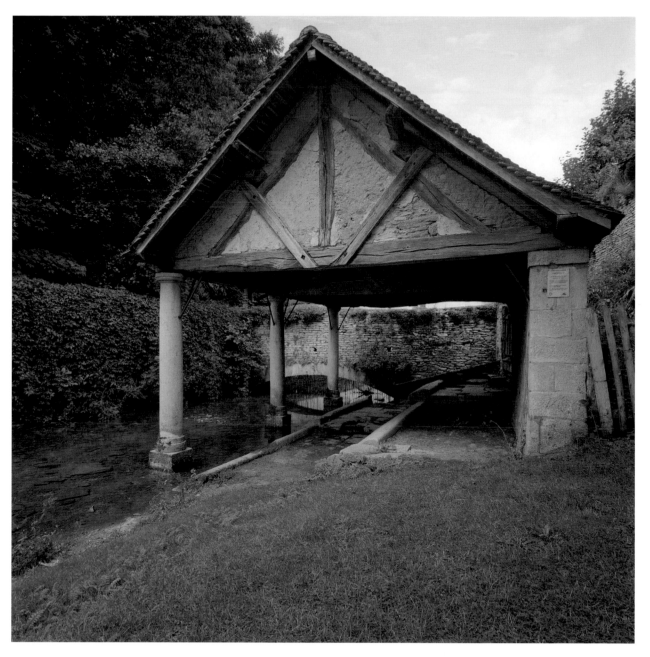

Lavoir sur l'Ignon, Lamargelle, Côte-d'Or, Burgundy, 1803, architect. Joseph Koernelle

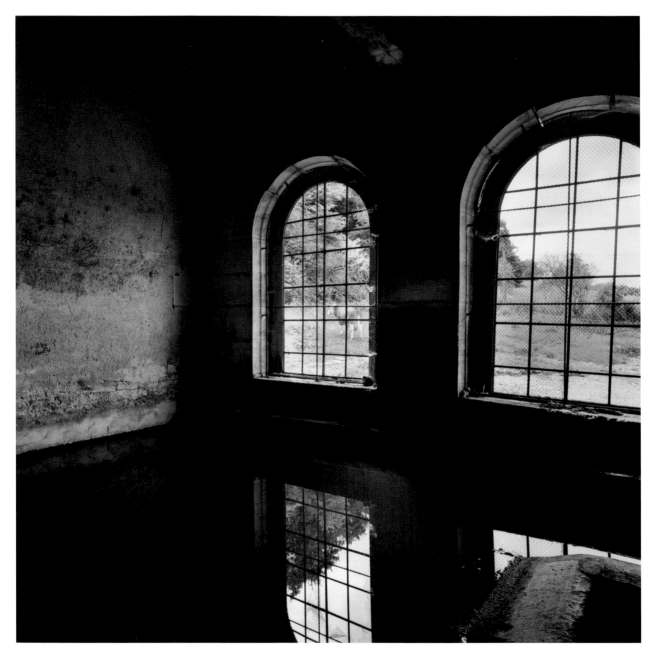

Luxerois, Côte-d'Or, Burgundy, nineteenth century

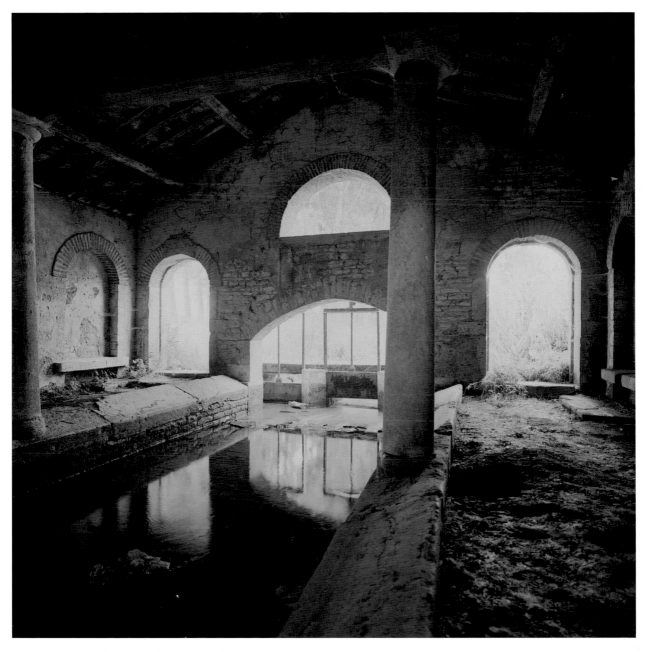

Lavoir sur la Bièvre, Tart-le-Haut, Côte-d'Or, Burgundy, 1843, architect: Lerond

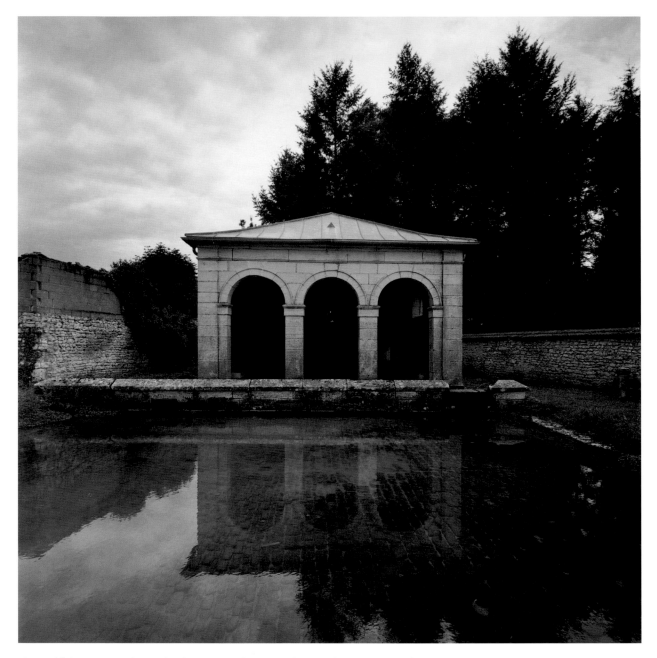

above and facing page: Lavoir du Fer à Cheval, Renève, Côte-d'Or, Burgundy, 1849, architect: Auguste Sirodot

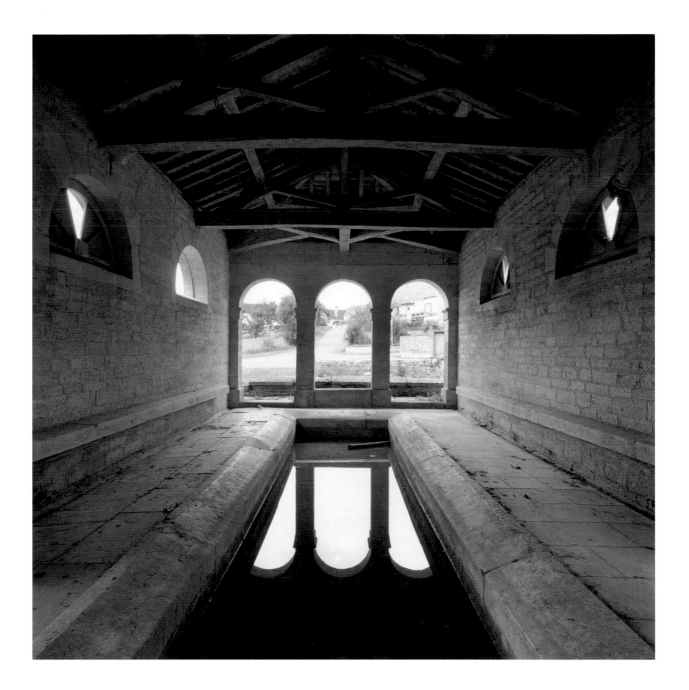

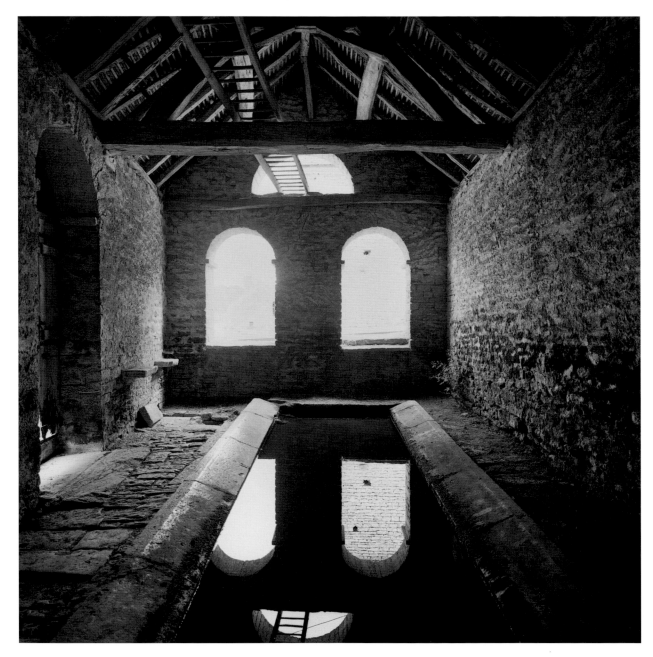

46

Lavoir du Ruisseau des Prêles, Quincy-le-Vicomte, Côte-d'Or, Burgundy, 1889, used today as a firehouse

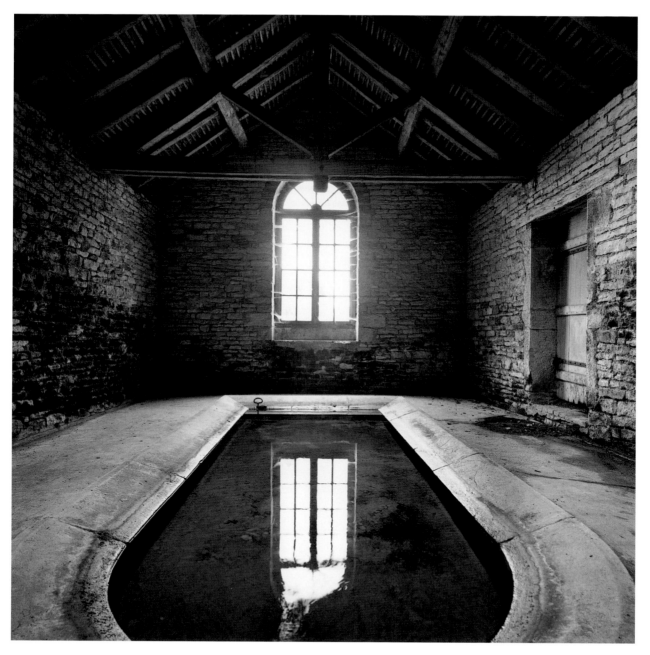

Lavoir de la Rue Fontaine, Senailly, Côte-d'Or, Burgundy, 1834, architect: Alexandre Rémond

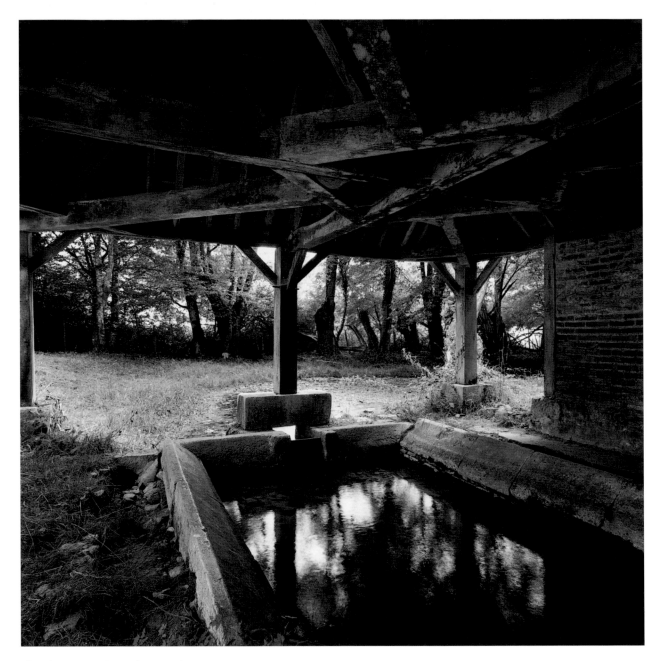

48

above: Asvins, Nièvre, Burgundy, nineteenth century

facing page: Bissy-sous-Uxelles, Saône-et-Loire, Burgundy, eighteenth century

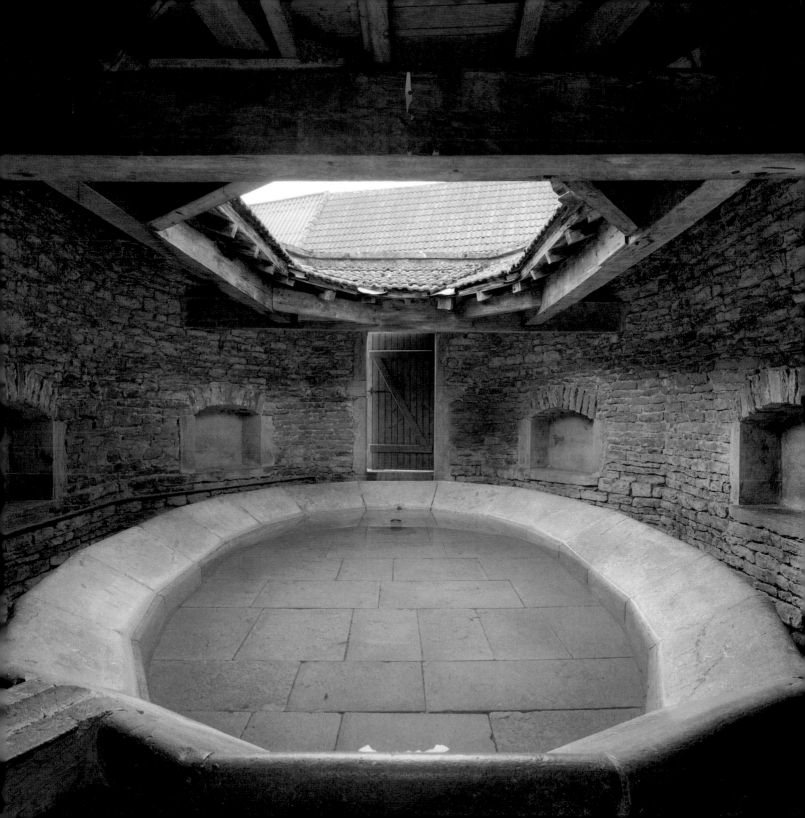

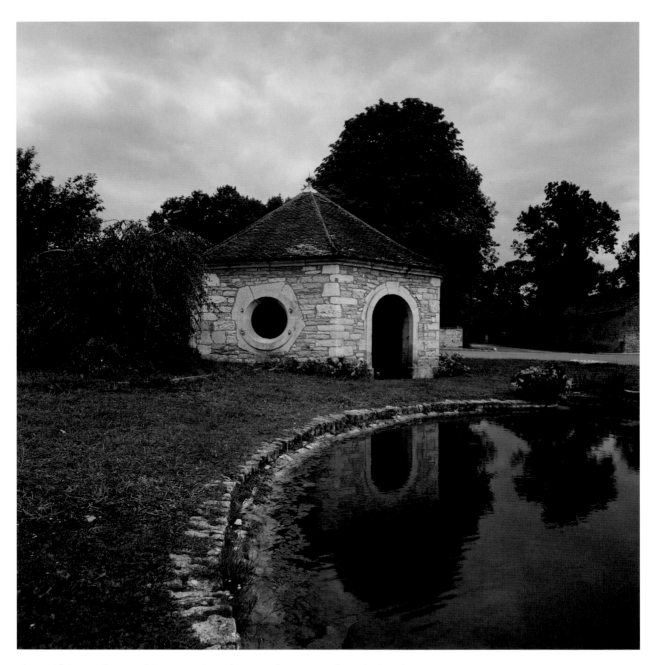

above and facing page: Fontaines, Saône-et-Loire, Burgundy, nineteenth century, one of seven *lavoirs* in the town

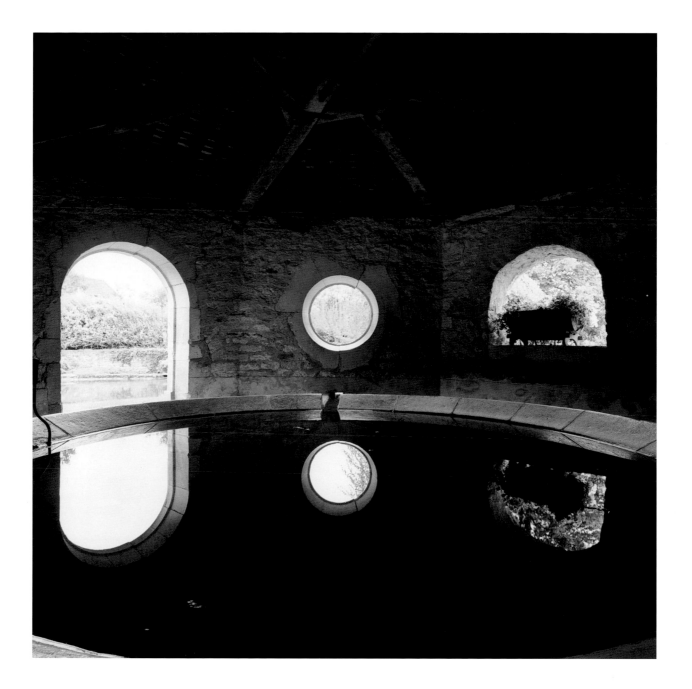

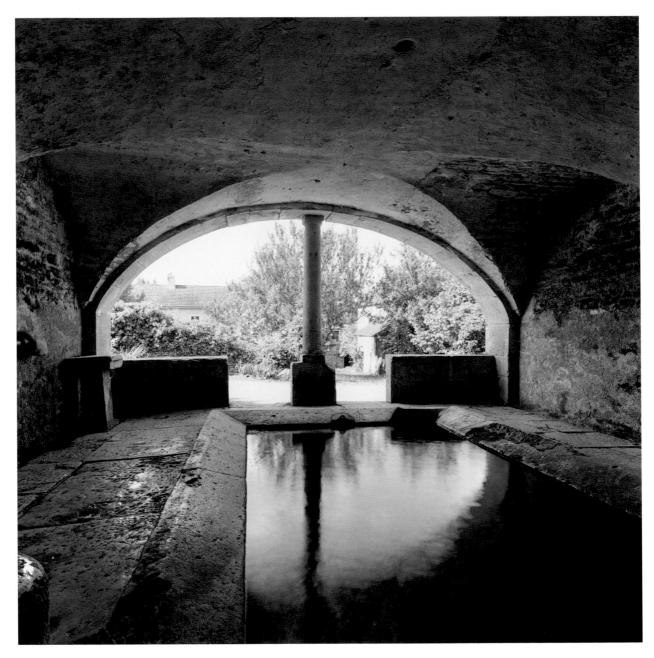

Lavoir du Château, Bierry-les-Belles-Fontaines, Yonne, Burgundy, 1648

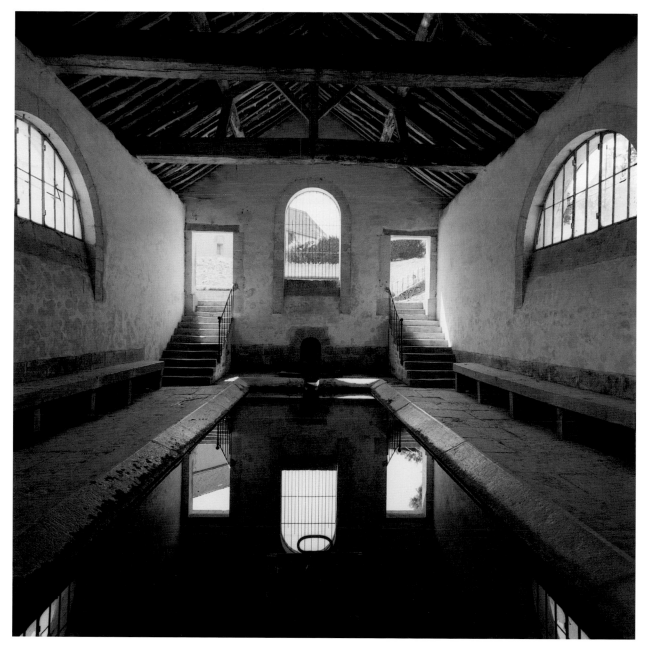

Lavoir de la Martine, Fouronnes, Yonne, Burgundy, 1819

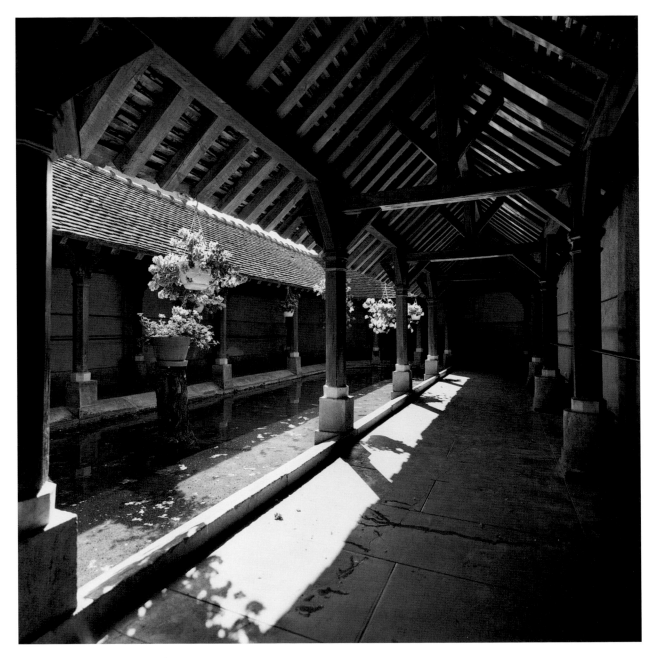

Gy-l'Evèque, Yonne, Burgundy, 1853, architect: Grégoire Roux

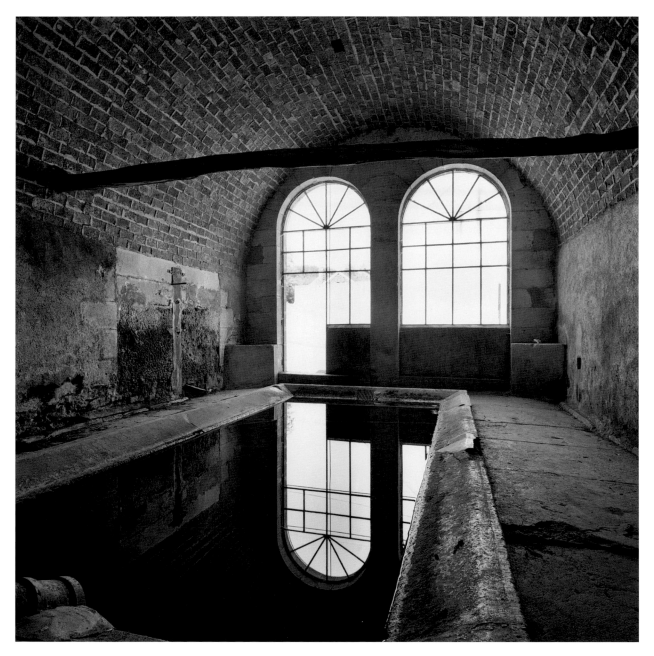

Lavoir du Centre, Lucy-le-Bois, Yonne, Burgundy, nineteenth century

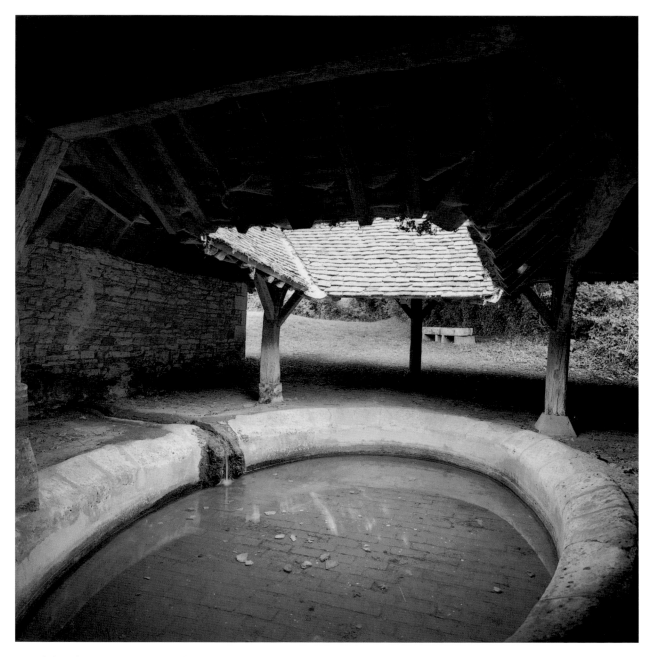

56

Lavoir de la Marlée, Perreuse, Yonne, Burgundy, eighteenth century

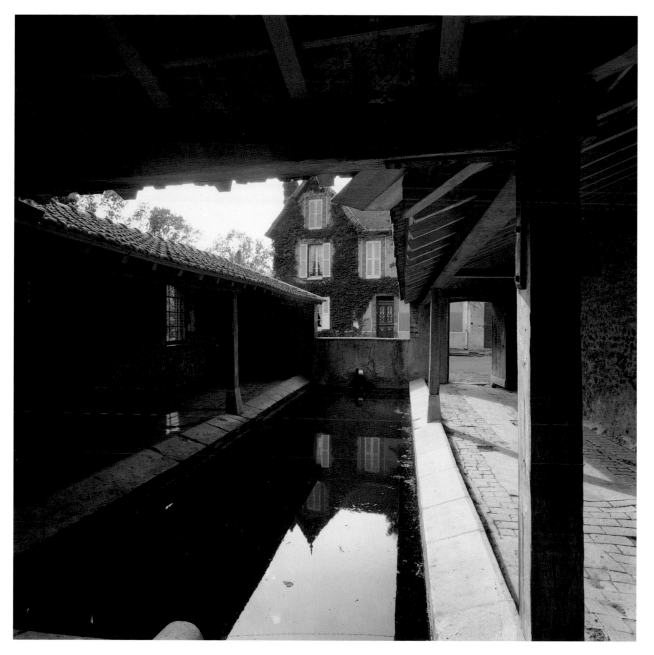

Saint-Aubin-sur-Yonne, Yonne, Burgundy, 1879

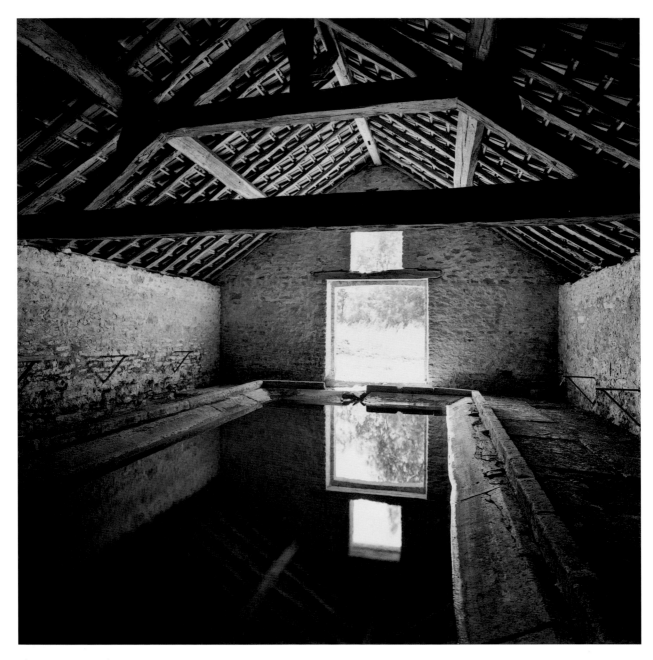

58

Tharot, Yonne, Burgundy, 1876

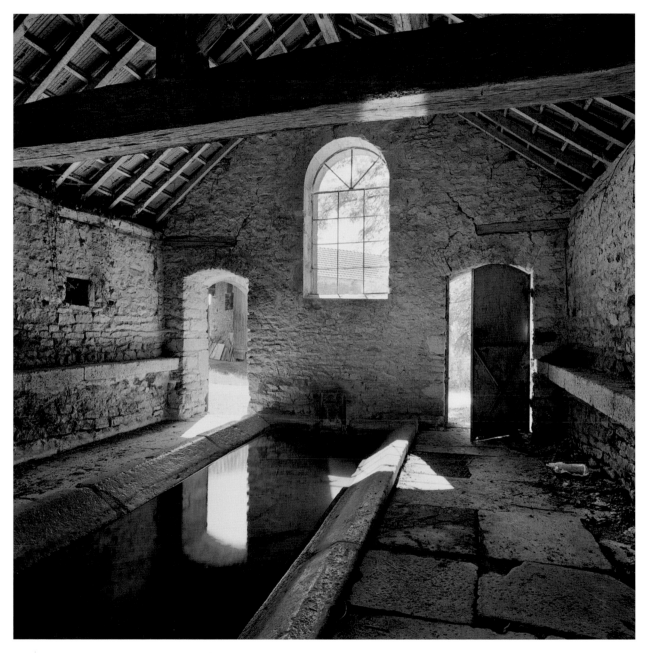

Lavoir de la Fontaine Daguin, Thory, Yonne, Burgundy, seventeenth century

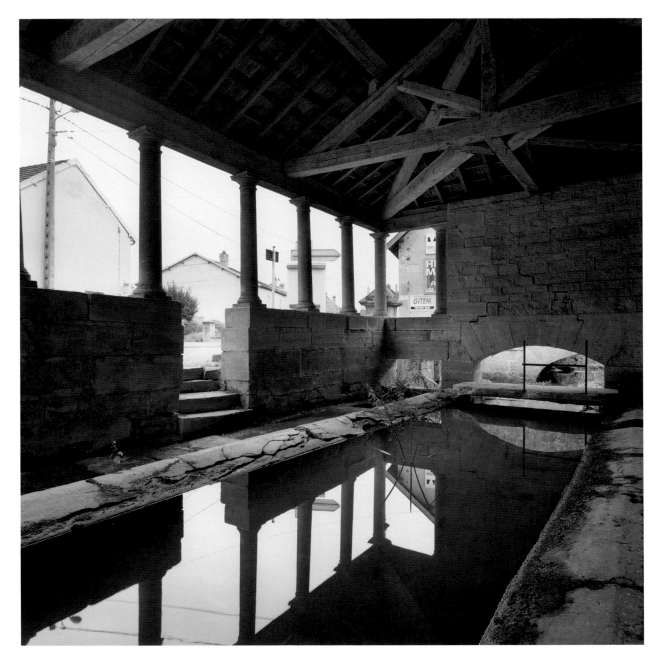

Lavoir Nord, Oyrières, Haute-Saône, Franche-Comté, 1846, architect: Delanne

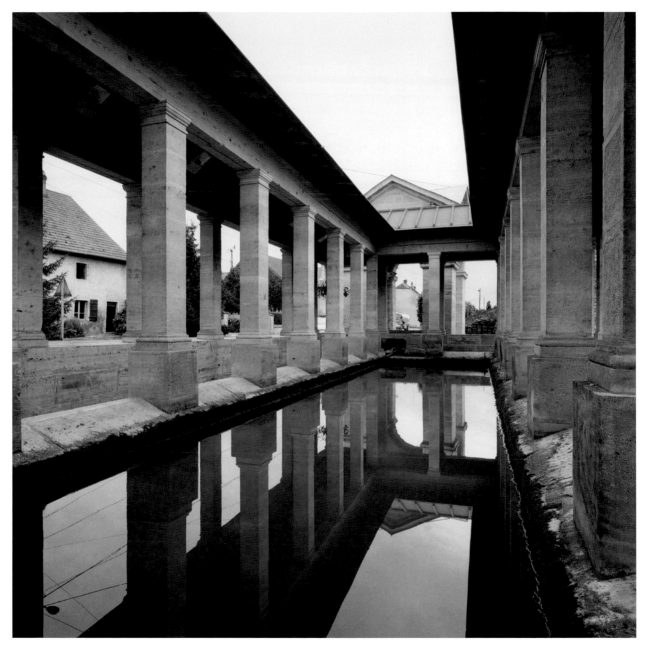

Lavoir Sud, Oyrières, Haute-Saône, Franche-Comté, 1830, architect: Louis Moreau

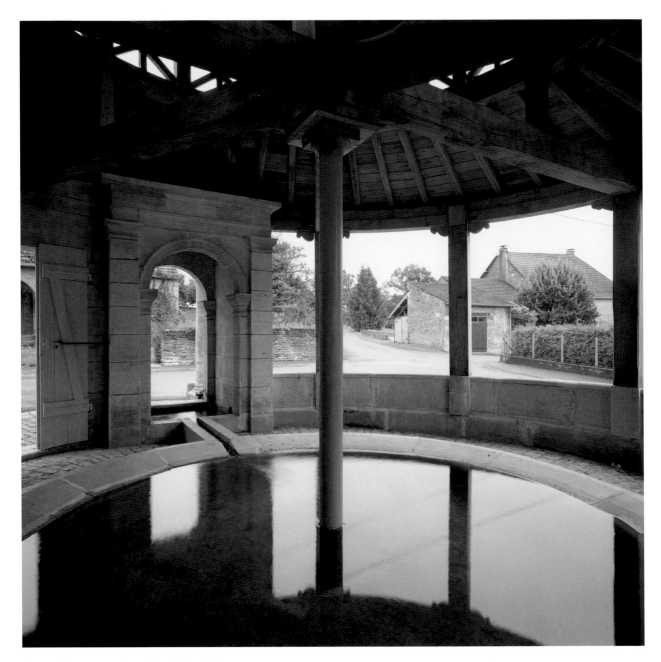

62

above: Confracourt, Haute-Saône, Franche-Comté, 1834

facing page: Semmadon, Haute-Saône, Franche-Comté, 1845

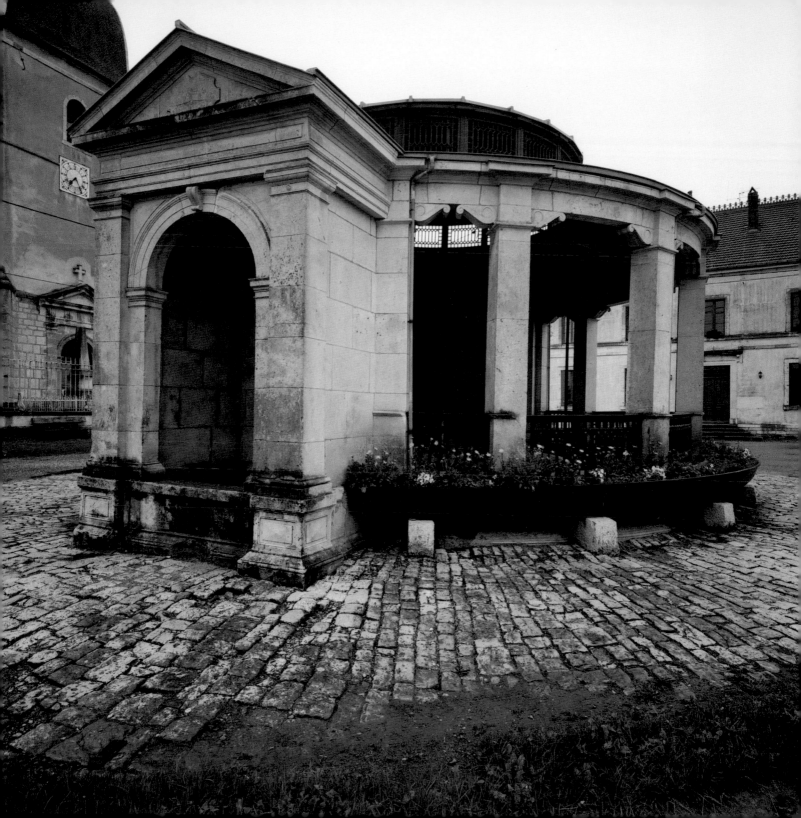

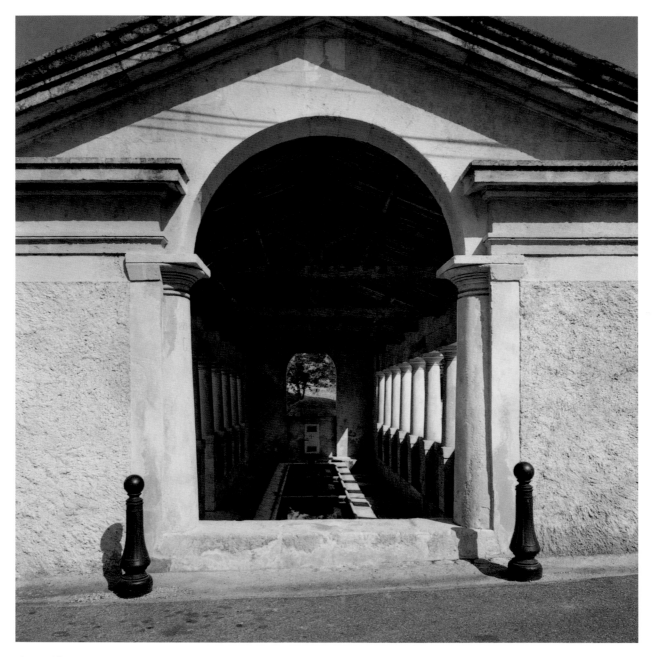

above and facing page: Bourg-Saint-Andéol, Ardèche, Rhône-Alpes, 1844

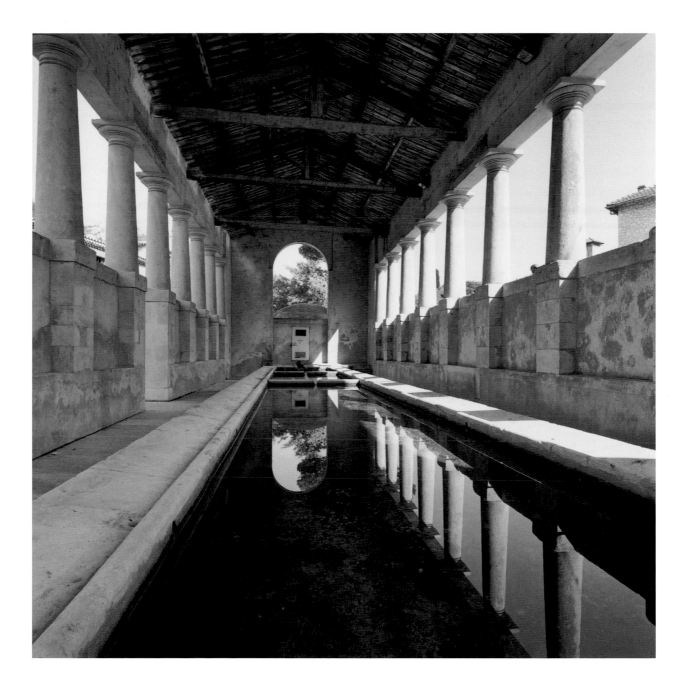

66

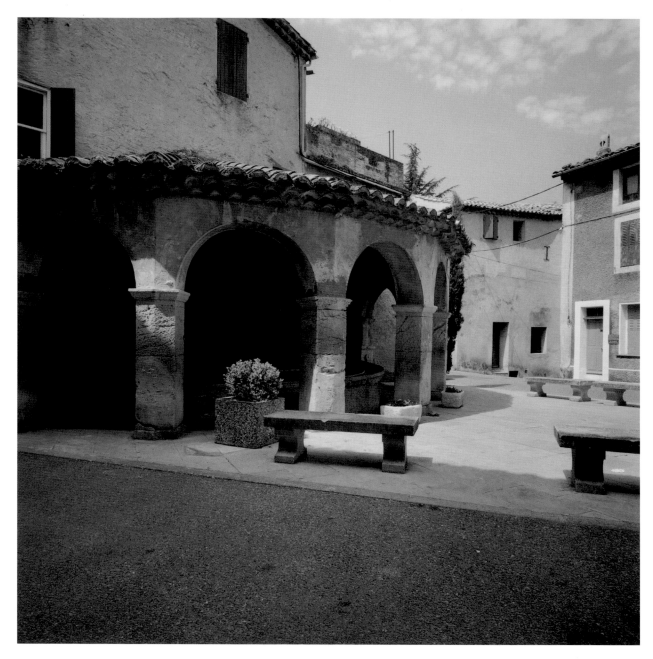

above and facing page: Mollans-sur-Ouvèze, Drôme, Rhône-Alpes, eighteenth century

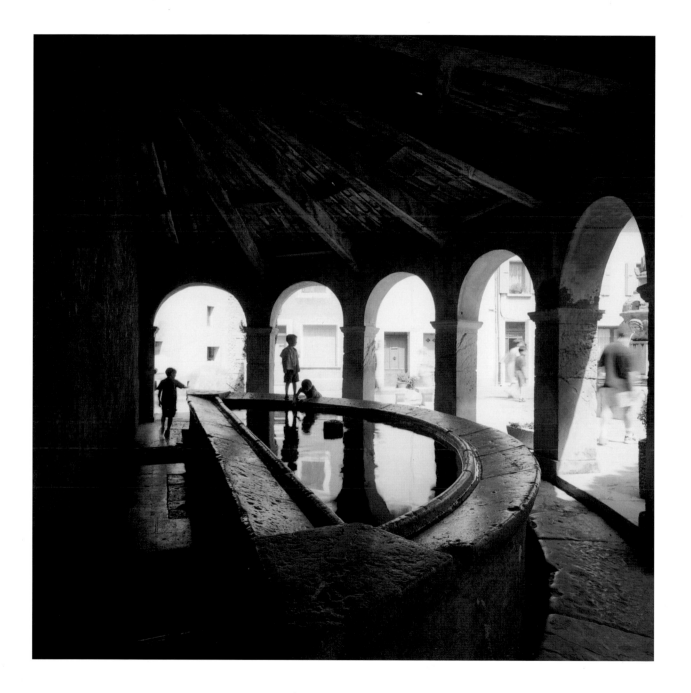

above and facing page: Les Retordier, Alpes de Haute-Provence, Provence, seventeenth century

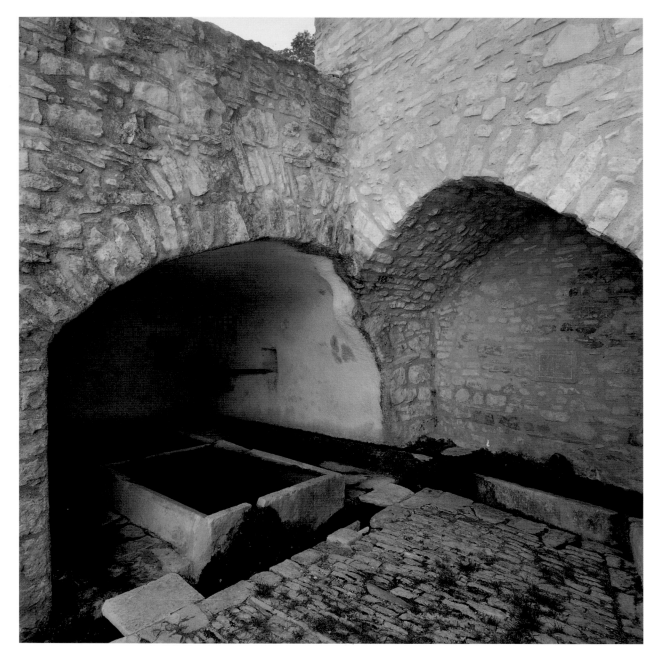

Lavoir de Dianne, Fontienne, Alpes de Haute-Provence, Provence, eighteenth century

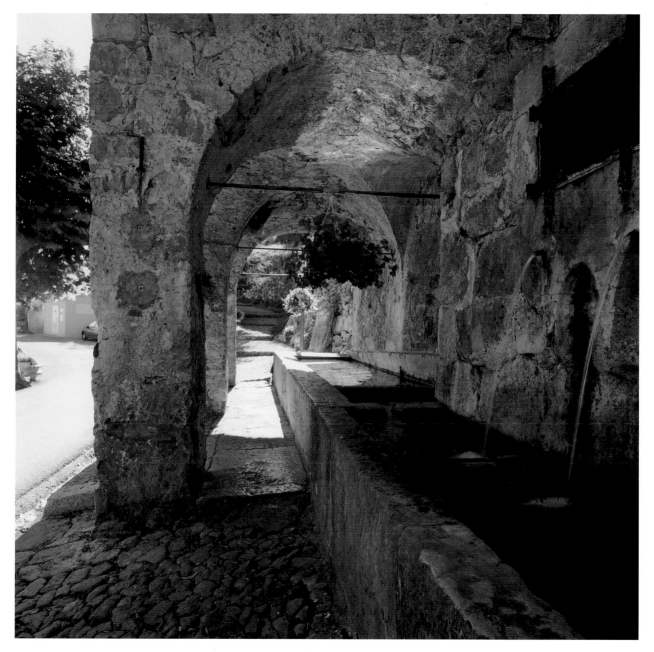

Toudon, Alpes-Maritimes, Provence, nineteenth century

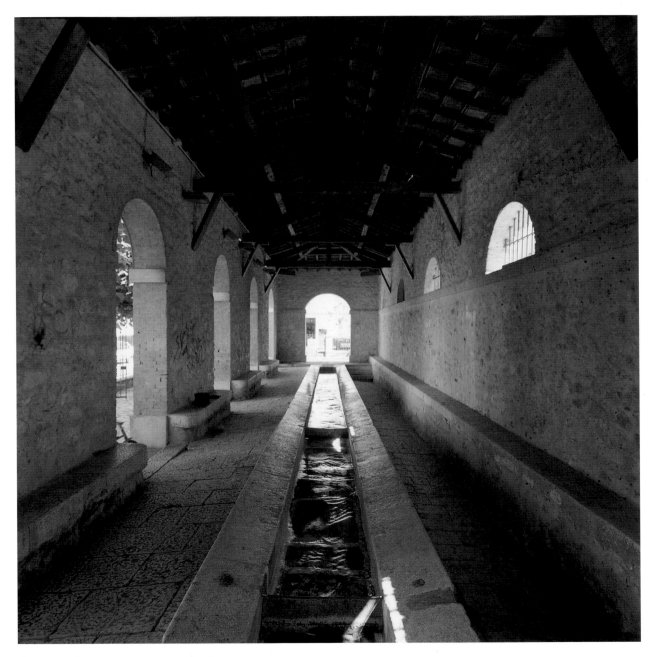

above: Vence, Alpes-Maritimes, Provence, nineteenth century

facing page: Aureilles, Bouches-du-Rhône, Provence, nineteenth century

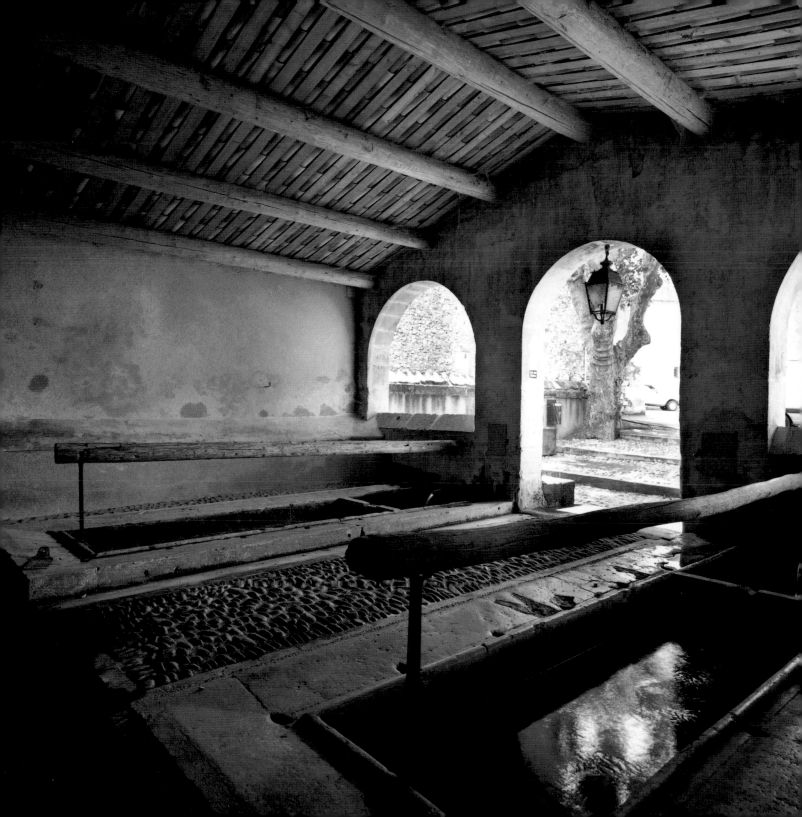

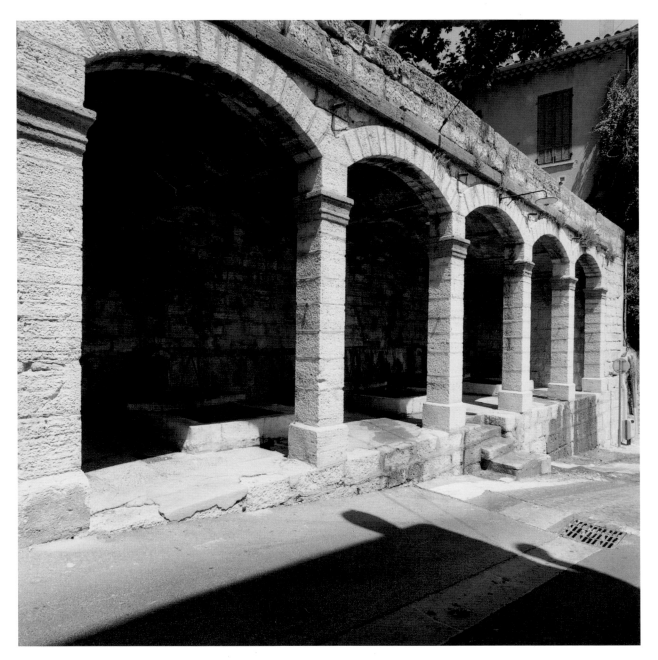

above and facing page: Eguilles, Bouches-du-Rhône, Provence, nineteenth century

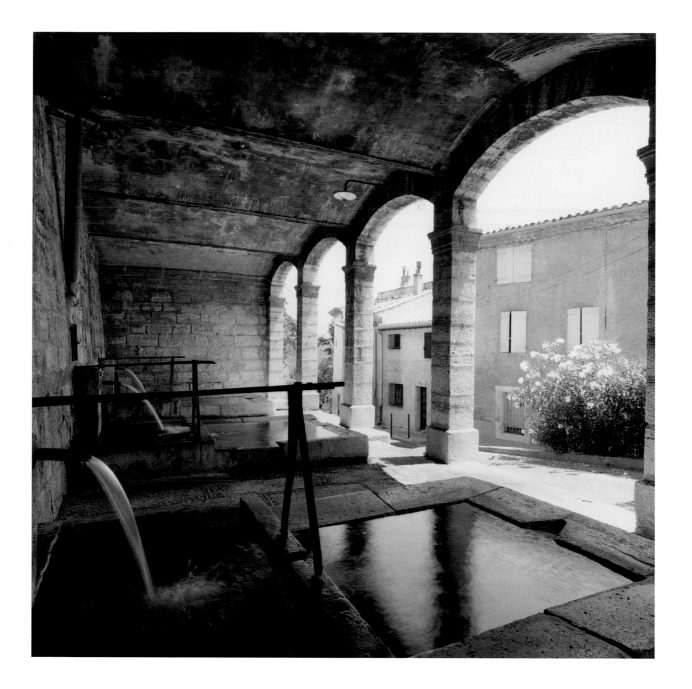

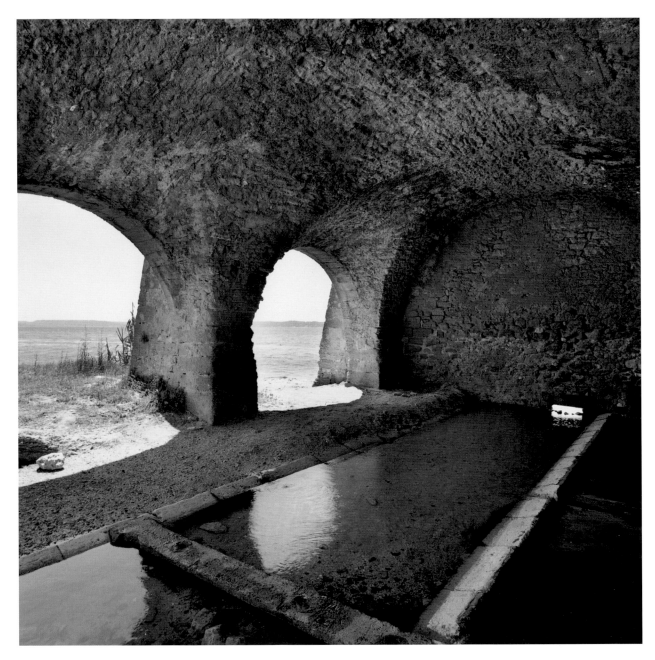

Lavoir du Polygone, Saint-Chamas, Bouches-du-Rhône, Provence, seventeenth century

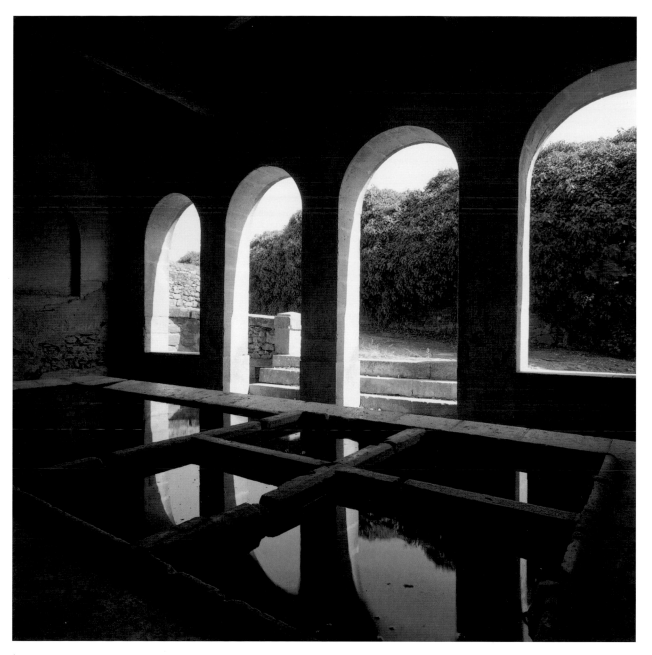

Lavoir du Mas Mathon, La Bruguière, Gard, Languedoc-Roussillon, nineteenth century

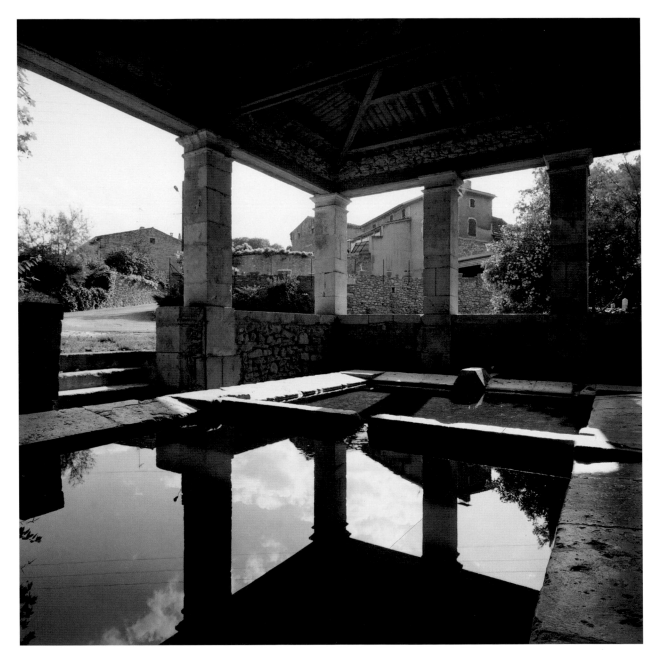

Saint-Laurent-des-Arbres, Gard, Languedoc-Roussillon, nineteenth century

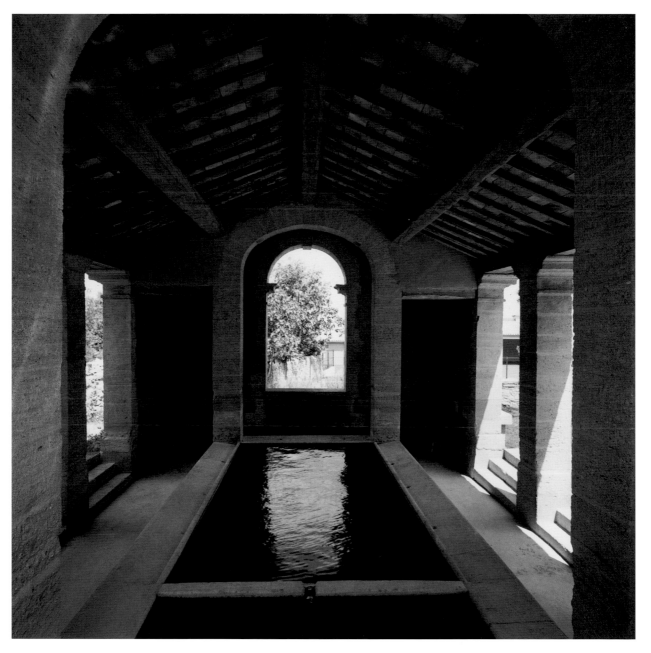

Saint-Victor-la-Coste, Gard, Languedoc-Roussillon, nineteenth century

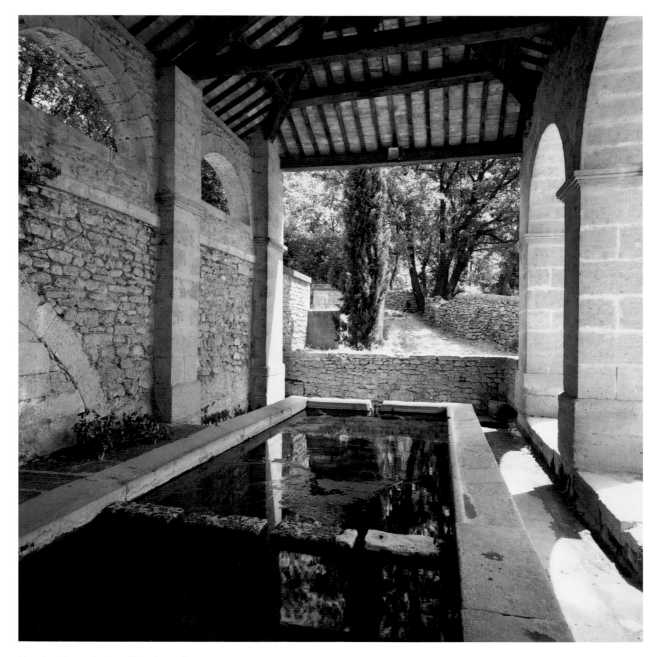

Vers, Gard, Languedoc-Roussillon, nineteenth century

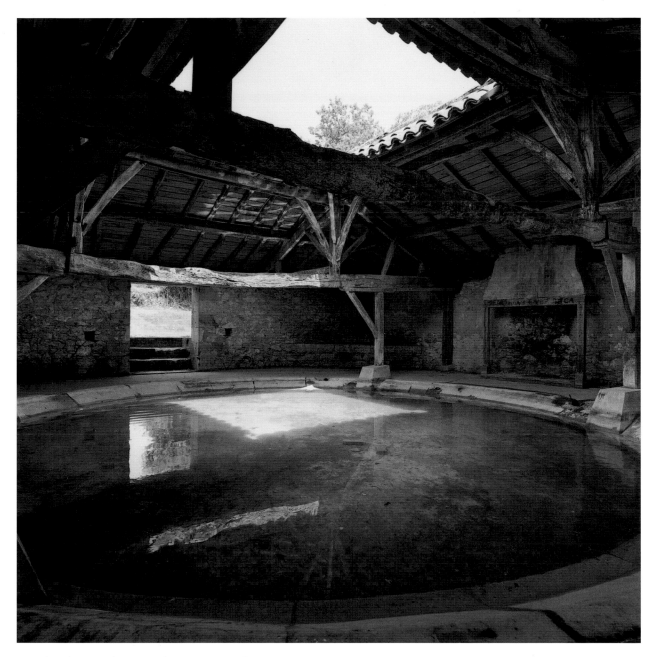

Lavoir de Lasdouts, Gondrin, Gers, Midi-Pyrénées, nineteenth century

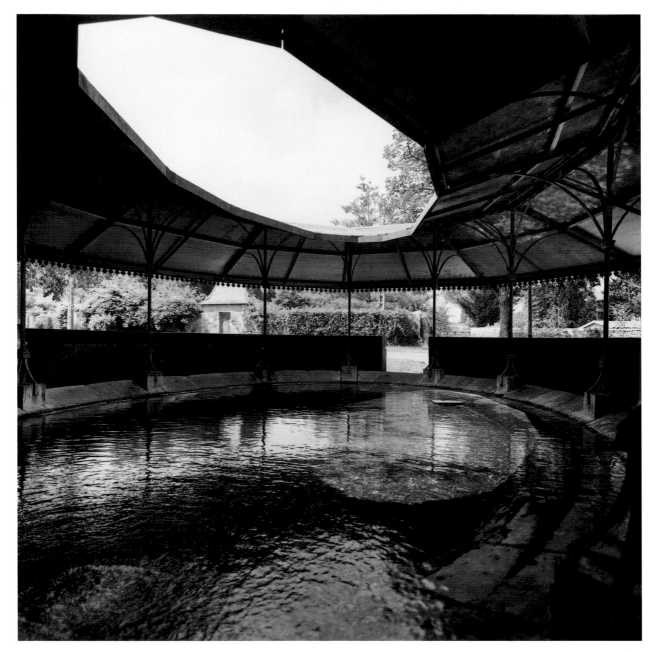

above: Manciet, Gers, Midi-Pyrénées, early twentieth century

facing page: La Bastide-d'Armagnac, Landes, Aquitaine, nineteenth century

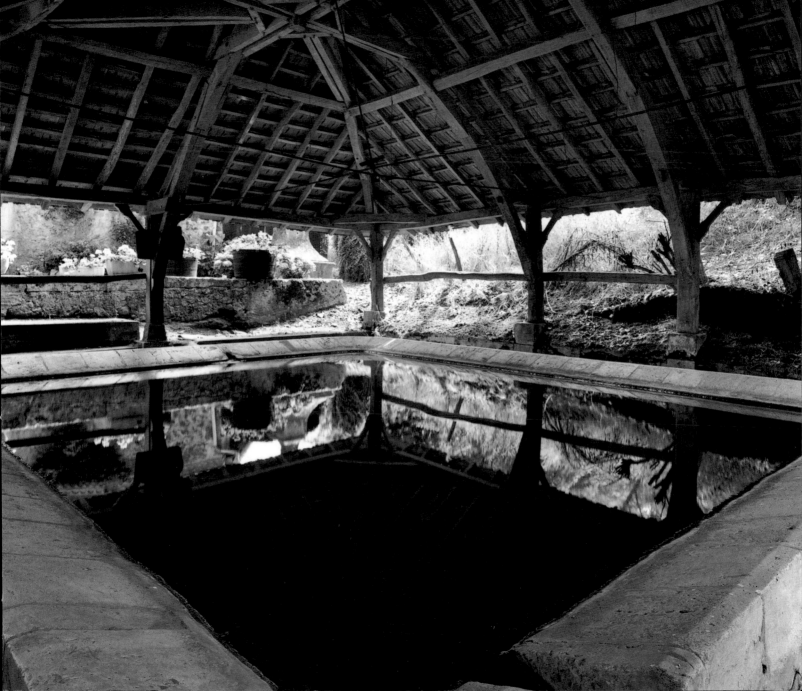

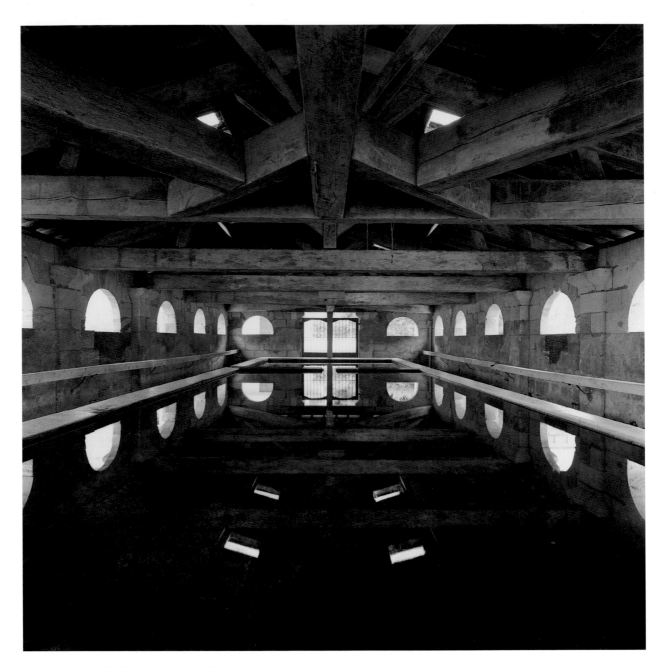

Bourg-sur-Gironde, Gironde, Aquitaine, nineteenth century

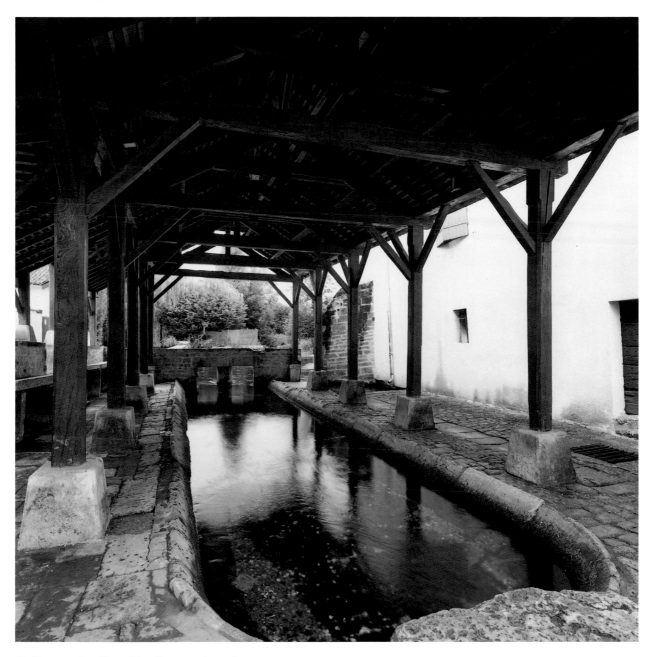

Chef-Boutonne, Deux-Sèvres, Poitou-Charentes, nineteenth century

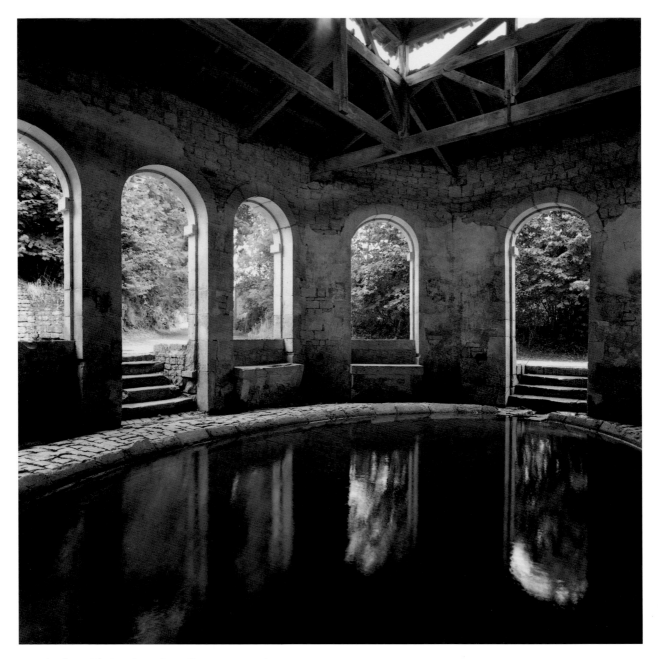

Lavoir de Villiers, Melle, Deux-Sèvres, Poitou-Charentes, nineteenth century

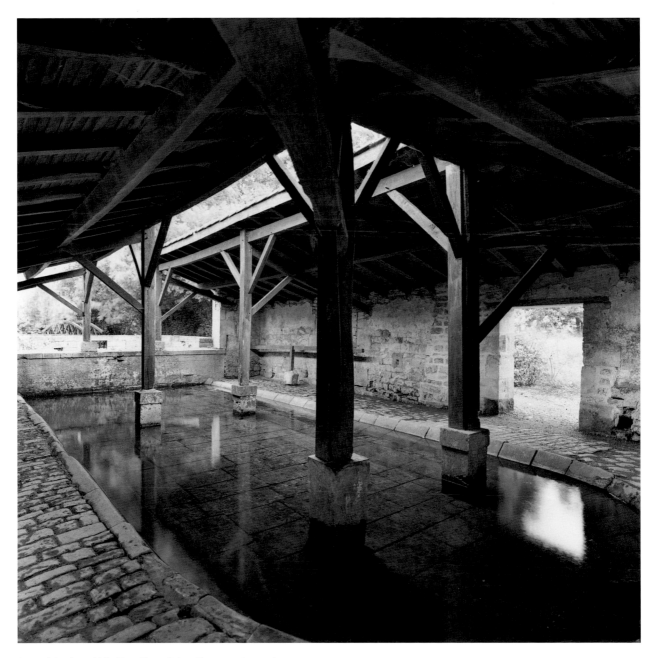

Lavoir du Loubeau, Melle, Deux-Sèvres, Poitou-Charentes, nineteenth century